EAST LOTHIAN

THROUGH TIME

Liz Hanson

AMBERLEY PUBLISHING

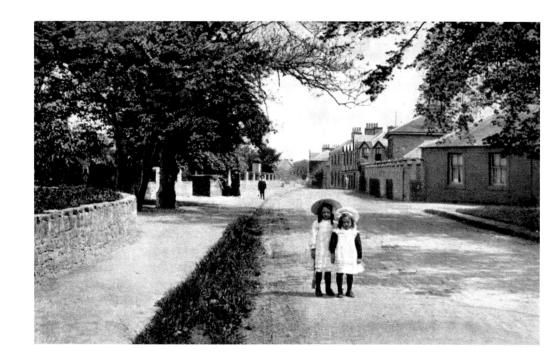

For Maggie

First published 2013

Amberley Publishing
The Hill, Stroud, Gloucestershire, GL5 4EP
www.amberley-books.com

Copyright © Liz Hanson, 2013

The right of Liz Hanson to be identified as the
Author of this work has been asserted in accordance with
the Copyrights, Designs and Patents Act 1988.

ISBN 978 1 4456 0758 0

British Library Cataloguing in Publication Data.
A catalogue record for this book is available from the
British Library.

Typesetting by Amberley Publishing.
Printed in Great Britain.

Introduction

The land mass of East Lothian is only about 300 square miles – seemingly insignificant in Scottish terms – but the location, situated as it is between Edinburgh and England, elevated the region to a position of strategic importance in previous centuries. It was also the closest entry into Scotland by sea from Europe, making it susceptible to attack.

Traces of prehistoric habitation have been found, the most exciting of which was the discovery in 2002 of a large timber house near Dunbar, dating from around 8000 BC. In the Lammermuir Hills, there are several small stone circles and a sizeable cairn, probably burial, known as the Mutiny Stones. Hill forts are also evident; the one on Traprain Law is the largest and is where the Gododdin people ruled and defended the surrounding fertile lands from Northumbrian Angles. A hoard of Roman silver was also unearthed here, although their short presence in the area was based at the Inveresk camp.

Christianity came early to East Lothian, and monasteries were founded in North Berwick, Haddington, Dirleton and Luffness, which were significant in bringing people to the region on pilgrimage. By the twelfth century, ferries were taking pilgrims across the Firth of Forth from North Berwick to Earlsferry in Fife, and from there they travelled to St Andrews. Many chapels and churches were built at this time, but most of these were destroyed after the Reformation, the leader of which, John Knox, was born in East Lothian.

Haddington, the administrative centre today, was made into a Royal Burgh in the mid-1100s by David I, helping it to develop into a market town selling the produce and animals from its intensely farmed hinterland at fairs around the mercat cross. The presence of an abbey, a Cistercian nunnery and a school paints a picture of wealth and social stability.

But all that was to change in 1298 when Edward I of England invaded, causing mayhem and widespread destruction, sadly a pattern that was to continue throughout the next few centuries. During 1356, having defeated the Scots at Berwick, Edward III continued north and attacked Haddington, burning the abbey to the ground. In 1544, Henry VIII sent Lord Hertford and his army north to give Edinburgh and the Scots a 'rough wooing'; the destruction and burning spread into East Lothian, concluding with the Battle of Pinkie in 1547, the last cross-border fight before Union of the Crowns in 1603. The Battle of Dunbar, fought against Oliver Cromwell, occurred in 1650. The final battle on East Lothian soil was between the Scots themselves. At Prestonpans in 1745, the Jacobite army, led by Charles Edward Stuart, defeated the Hanoverian government troops in a short, vicious fight, a sight purportedly watched by many from the tower of the parish church.

Life on the land also became troublesome, notwithstanding the destruction caused by English incursions. During the fourteenth century, climatic changes badly affected agricultural yields creating famine, economic decline and sickness, compounded by the arrival of the Black Death. The shortage of farm labourers meant that the survivors were treated somewhat better by the landowners.

After the Treaty of Union was signed in 1707, East Lothian became a more settled place and farms began to grow larger, adding the newly introduced potato to the list of crops. Improvements and new inventions, particularly the swing plough, helped efficiency, albeit at the cost of jobs for labourers.

By the nineteenth century, it was not only agriculture that was flourishing. Fishing, at its height in the late 1880s with the herring boom, saw boats sailing out of Fisherrow, Cockenzie, Port Seton, North Berwick and Dunbar. There were nine distilleries utilising the local barley, coal was being mined from the seam running under Ormiston, Tranent and Prestongrange, and salt was produced at Prestonpans. Other small industries such as pottery and woollens sprung up, but have not endured.

The low-lying, gentle sand dunes along the coast lend themselves beautifully to the game of golf, which has been played at Musselburgh since 1672, making it one of the oldest courses in the world. There are twenty-two golf courses in the county – the Open Championship of 2013 took place at Muirfield – and the sport contributes significantly to the region's economy.

East Lothian has recovered from the woes of past times to become one of the most attractive parts of Scotland in which to live or visit. The lowlands between the heather moorland of the Lammermuir Hills and the splendid coastline are peppered with red pantiled buildings and picturesque villages, fringed with native woodlands. The twenty-first century is a good time to be in East Lothian.

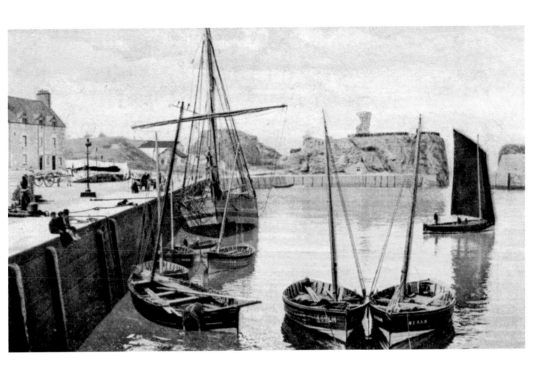

Dunbar Castle

In Gaelic, *dun-barr* means 'fort on the point'. The importance of Dunbar as a port and garrison town is hardly surprising, given its location halfway between Berwick and Edinburgh, where the Firth of Forth merges with the North Sea. In 1072, Malcolm Canmore, King of Scotland, granted Dunbar and the lands of Lothian to Gospatric (the previous Earl of Northumberland), and the local history for the next 350 years revolves around these Earls of Dunbar and Wemyss. It was likely that they built the impregnable Dunbar Castle in the early twelfth century. Nowadays, the ruins are only of use to the kittiwakes that nest on the walls.

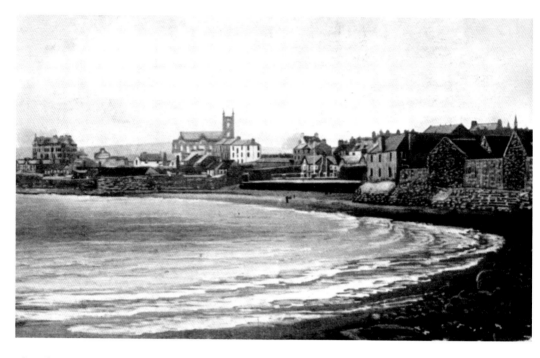

View from Old Harbour, Dunbar

A small 'free' harbour existed at the mouth of Biel Water in the fourteenth century but, by 1574, Dunbar had its own, east of the castle. Following the ravages of the 'rough wooing' by the English in 1544, the Battle of Dunbar in 1650 and damage from storms, the harbour was in a sorry state. The town appealed for help to the government who granted £300 for repairs and thus it became known as Cromwell's harbour. More recently, the entry to Broad Haven, the small harbour formed by the causeway to Lamer Island, has been infilled.

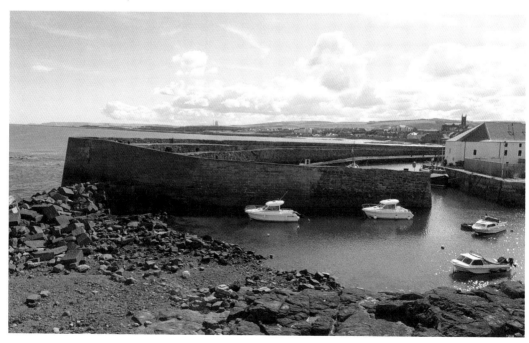

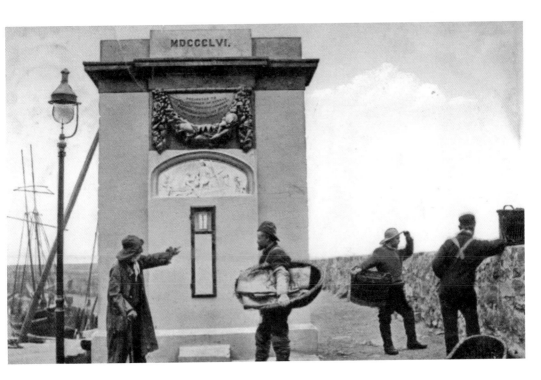

Barometer Pedestal at Old Harbour

The barometer is no longer present, but the sentiment of the inscription on this 1861 structure says it all: 'Presented to the Fishermen of Dunbar to whose Perilous Industry the Burgh owes much of its Prosperity.' Relief plasterwork depicts a fisherman leaving his family.

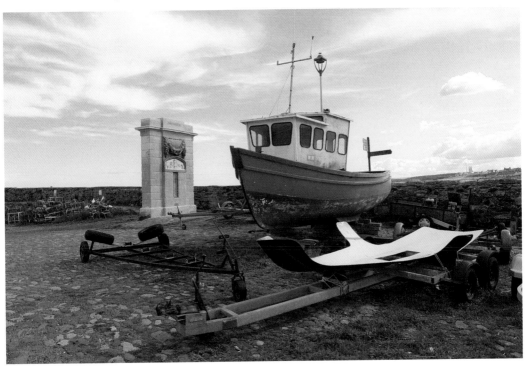

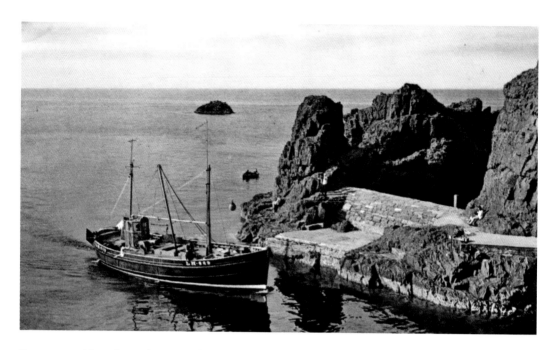

Entrance to Victoria Harbour, Dunbar

The precipitous rocks seen in the photographs are those on which Dunbar Castle was built, a position so vulnerable to attack that it was deliberately demolished in 1488. It was rebuilt by James IV soon after he became King of Scots, and a blockhouse was added on the landward side in the 1520s, possibly by the Duke of Albany's French faction. Then, in 1567, Parliament ordered the destruction of the fortification. Storms and waves have subsequently worn the sandstone down further, but more damage was done to the fragile remains when this entrance to the new Victoria Harbour was made in 1842.

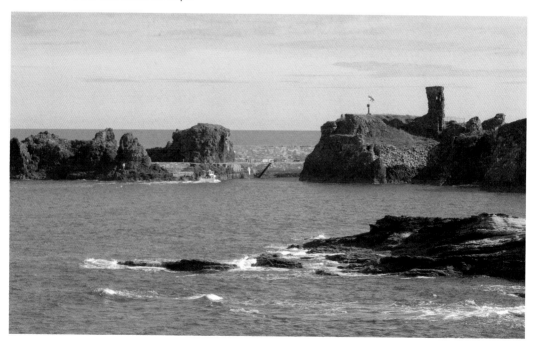

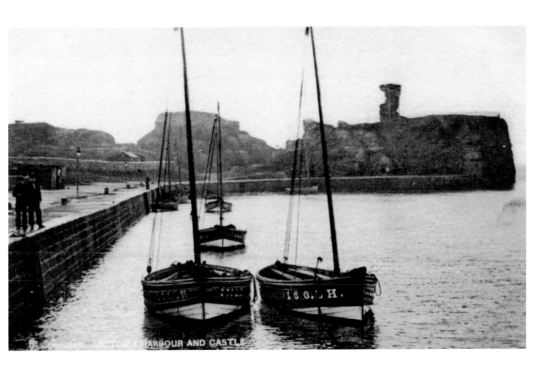

Victoria Harbour

The eighteenth century was a prosperous time for trading goods like grain, timber and cloth with Europe, and one family – the Falls – built the imposing Dunbar House with their proceeds. The 'new' nineteenth-century Victoria Harbour, on the other hand, was filled with fishing boats, due to the herring boom of the mid- to late 1800s, when 700–800 vessels were operating out of Dunbar. The harbour needed to be improved in 1858 to accommodate the fleet. Only a few small fishing boats can be seen moored here today.

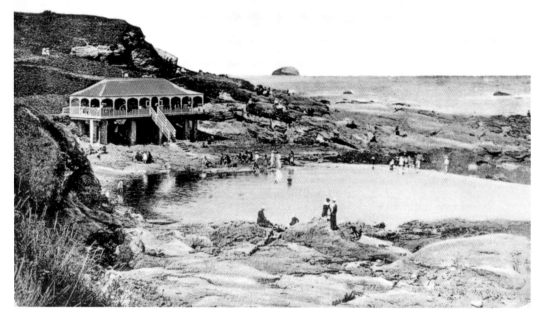

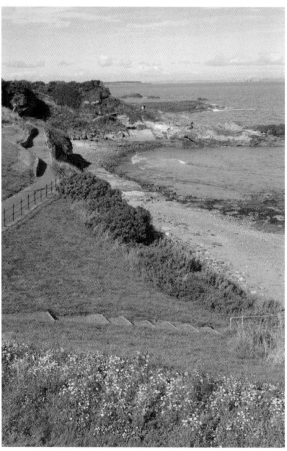

Ladies Bathing Pool, Dunbar

In 1846, the North British Railway opened the line between Edinburgh and Berwick, which brought holidaymakers to the attractions of coastal towns like Dunbar. Visitor numbers soared and the town council recognised that better bathing facilities were needed. In 1886, a basic changing house and pool were completed in a small, sheltered, rocky bay west of the harbour. The more elaborate pavilion in this picture was erected in 1904, followed by the creation of a boating pond in 1928 and modernisation to the pavilion. The site was dismantled in 1984. A state-of-the-art leisure pool and health club now graces the clifftop above the ruins of the castle.

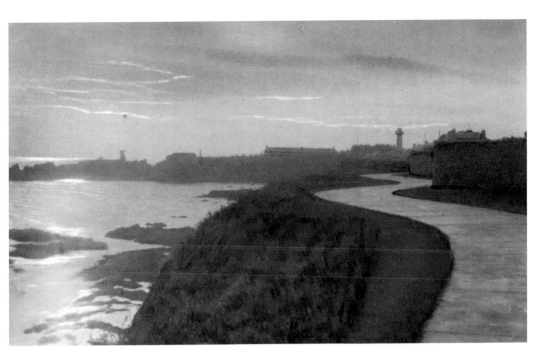

Clifftop Esplanade

The walk from Dunbar to Belhaven Bay can be done along the winding (and often windy) clifftop pathway between the sea and Bayswell Park, affording stunning views across the Firth of Forth to Fife and beyond. Dunbar Town Council created the west promenade with funds gifted by Lady Baird Hay.

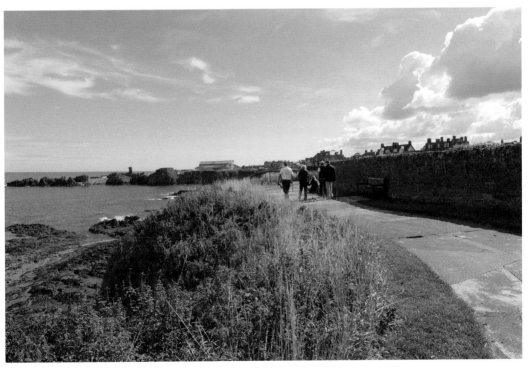

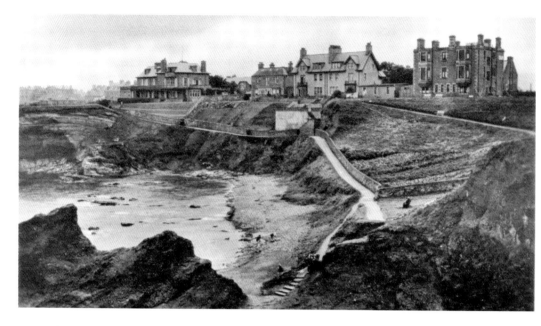

Bayswell Park

John Muir, born in Dunbar in 1838, is considered to be the father of conservation. His family immigrated to Wisconsin when he was only eleven but he subsequently founded the National Park movement in America, Yosemite being synonymous with his name. It is appropriate that the contemporary John Muir Way starts at Dunbar Castle, the path then drops into the rugged Bayswell Bay before continuing on above the sheer cliffs to Belhaven (*see inset*). It does not compare to the true wilderness, so beloved by him, but it is rich in both wildlife and seascapes.

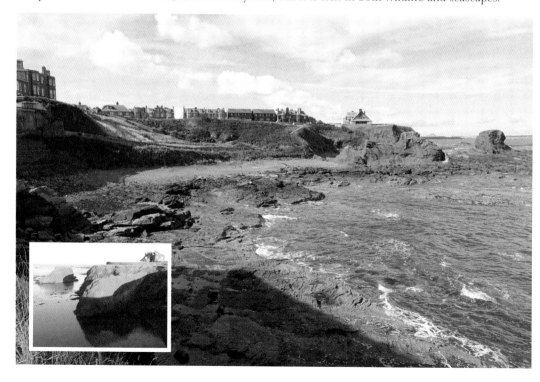

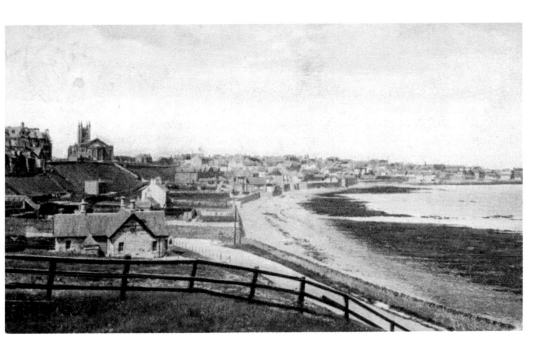

Dunbar from the Golf Links

There are records of golf being played at Dunbar for almost 400 years, although the original location was at West Barns, but during the Napoleonic Wars this site was used for military exercises. In 1856, work began on the links south-east of the town, developing a 15-hole golf course, increasing to 18 holes in 1880, while the Duke of Roxburghe granted use of his property ('Beachcote', which is seen in foreground of old photograph) for a clubhouse. It was not until 1938 that the ban on Sabbath playing was lifted.

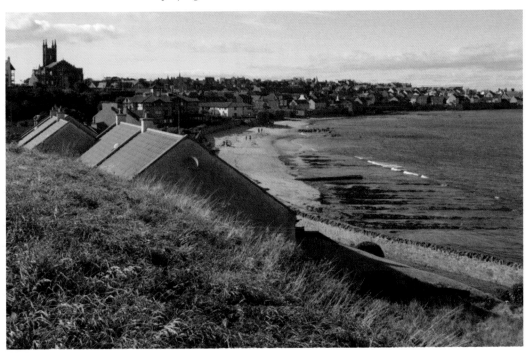

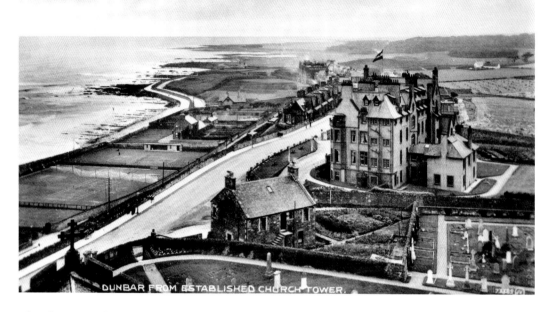

DUNBAR FROM ESTABLISHED CHURCH TOWER.

View from Parish Church Tower

The tall pinnacles of Dunbar parish church tower are commanding landmarks for miles around. Built in the local red sandstone (1818), this building replaced a large collegiate church of 1342 on the same site. The interior was badly damaged by fire in 1987. Restoration took four years to complete and a cross made from two charred beams is placed below the central window. Further along Queen's Road, just visible in the older picture, was the Roxburghe Marine Hotel, built in 1885, but demolished a century later.

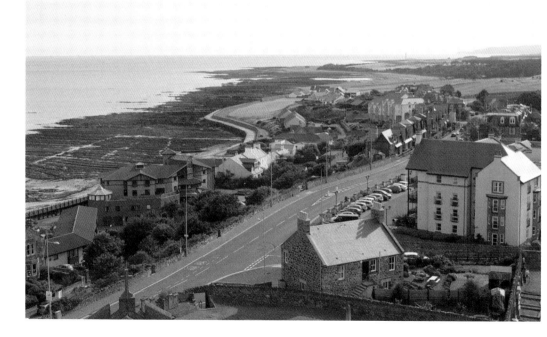

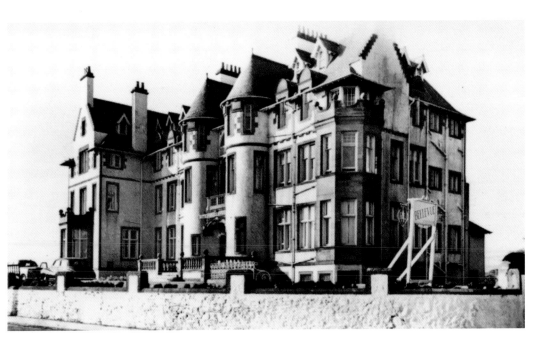

Bellevue Hotel

Adjacent to the parish church, the Bellevue Hotel formed an equally striking outline in the Dunbar townscape. It was opened in 1897 with high hopes that the ambitious fifty-bedroomed hotel would vie for business with the large prestigious rivals in nearby North Berwick. In 1989, a huge fire spread through the building, injuring some of the seventy firemen tackling the blaze. In 2003, developers applied to convert the structure into luxury flats with the original façade in situ but, having been deemed unsafe, the entire building was pulled down in 2006. The new Belle Vue Court, comprising fifty-two apartments, is not dissimilar to the original architectural design.

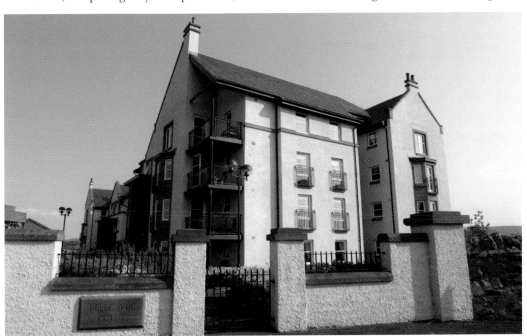

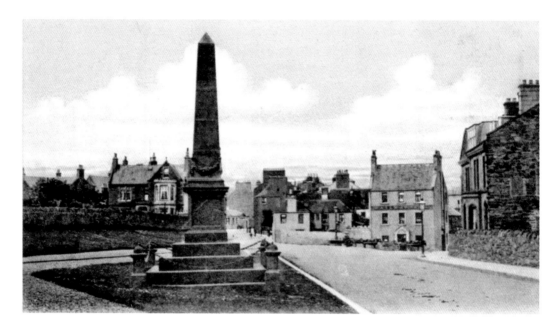

Yeomanry Monument

The Imperial Yeomanry was made up of volunteer forces willing to fight in the second Boer War and did not take part in any subsequent conflicts. The obelisk memorial to the dead soldiers is on Queen's Road, where a cottage hospital was opened in 1927 to replace the small military Battery Hospital used throughout the First World War. The former house was demolished in 1984, by which time patients were being treated in Belhaven Hospital. General practitioners now consult from the modern medical centre, which lies to the left of the memorial.

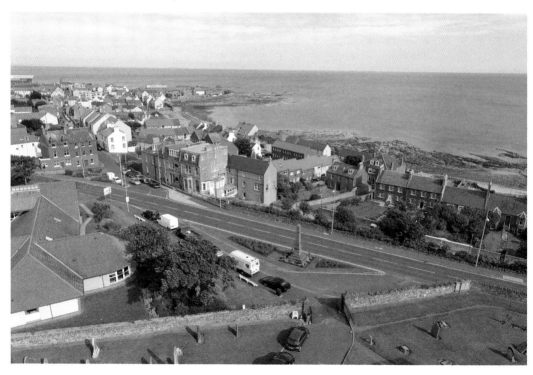

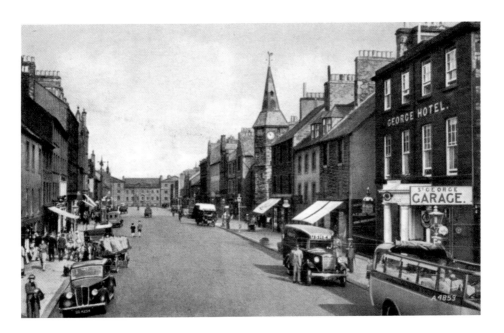

Dunbar High Street

The northern end of this wide street is the oldest, dating from the eighteenth century, with smart Georgian buildings to the south emerging as the town expanded. The bulk of Lauderdale House punctuates the thoroughfare just above the harbour. It was first built in 1740 by Captain James Fall MP, who named it Dunbar House. Captain Fall's family were prosperous merchants, but they became bankrupt and needed to sell the property. The Earl of Lauderdale then purchased it; he immediately changed its name and employed the architect Robert Adam to enlarge it. Used as barracks in 1859, it is now divided into flats.

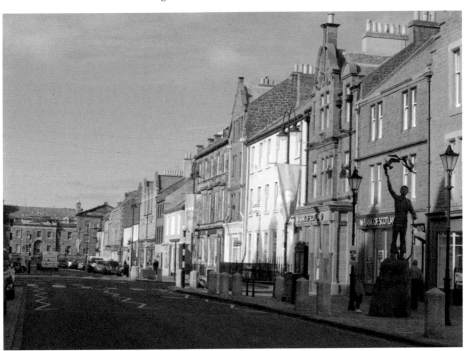

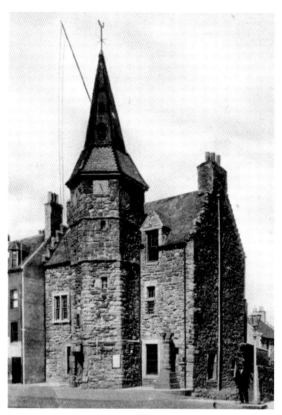

Dunbar Town House

This attractive late sixteenth-century building, halfway along the High Street, is the oldest in the town. It is built of local red sandstone, which has been covered with cream harling as part of a major refurbishment. The unusual steeple, which has oval vents, tops the five-sided tower, on two faces of which (north and south) are the town clocks. The former tolbooth (town house) was utilised continuously for council administration until the local government reorganisation in 1975, the council chambers being on the top floor. It is now open to the public as a museum and gallery, run by East Lothian Council, as well as being the base for Dunbar & District History Society. A statue of John Muir as a boy has been erected outside the town house.

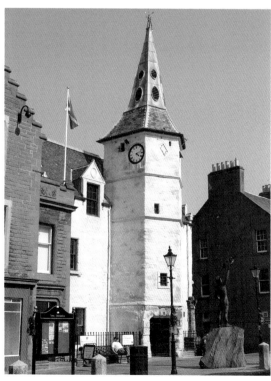

Barns Ness Lighthouse

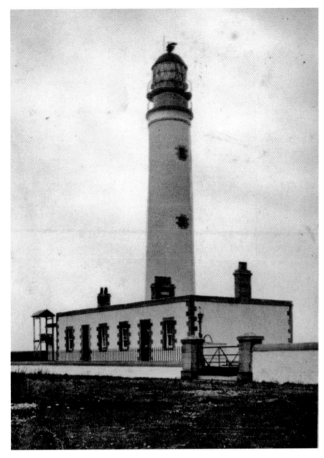

Lying just south of Dunbar, the 121-foot-high lighthouse started operating in 1910, having been built by David A. Stevenson over a two-and-a-half-year period. The two adjacent cottages housed the keepers, but in 1966 the operation was changed to semi-automatic, which only required one person, and, by 1986, the light was controlled fully from Northern Lighthouse Headquarters in Edinburgh. The final blow came in 2005 when the General Lighthouse Authority undertook a major review of navigational aids around the UK and deemed that the beam from Barns Ness was no longer required. At the time of writing, the cottages are unoccupied but the lighthouse is being used for abseiling!

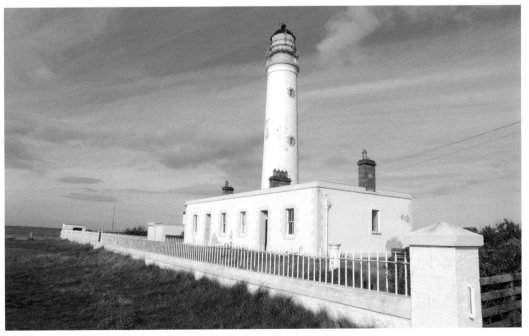

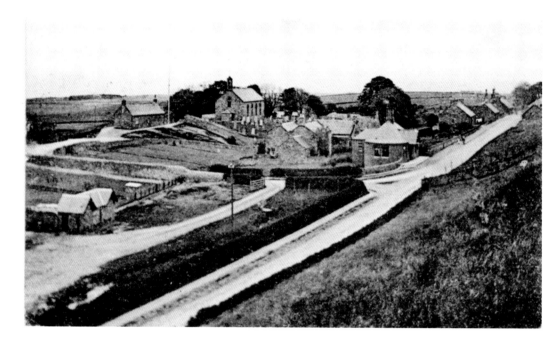

Innerwick

This conservation village lies on the south-eastern fringe of the county, straddling two parallel ridges, giving it commanding views to the North Sea. Most buildings are from the eighteenth and nineteenth centuries, and were originally used by farm labourers. As agriculture became more mechanised, fewer people were employed on the land and the properties are generally privately owned now. Electricity and mains water did not reach the community until the 1950s, although there was a railway station, which closed in 1963. At the local harbour of Skateraw, there is a well-preserved limekiln; lime was an important material in the agricultural improvements in the eighteenth and nineteenth centuries. Torness nuclear power station, sited nearby, boosted local employment and is expected to operate until 2023.

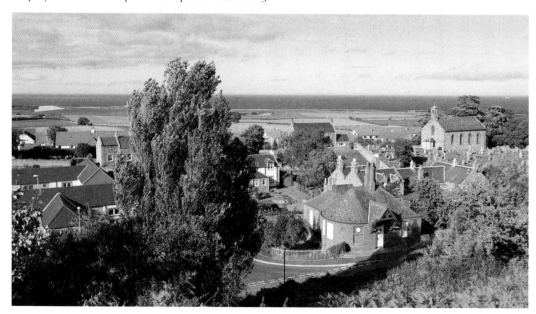

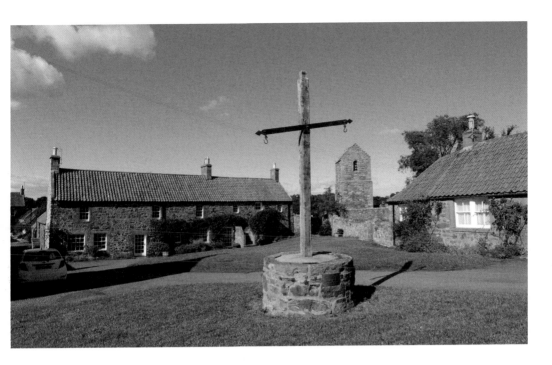

Stenton

The intense pink/red tones of the stone buildings, together with three greens (east, mid and west), make this one of the most colourful communities in East Lothian, designated an Outstanding Conservation Area. The name is derived from 'stane' or stone town but it used to be in the parish of Pitcox, a neighbouring village. Remains of the old church tower (1525) are impressive but dwarfed by the gothic parish church of 1829, designed by William Burn. The tron was renovated by local girl guides in 1970.

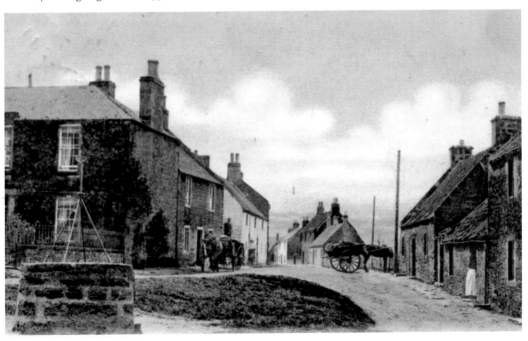

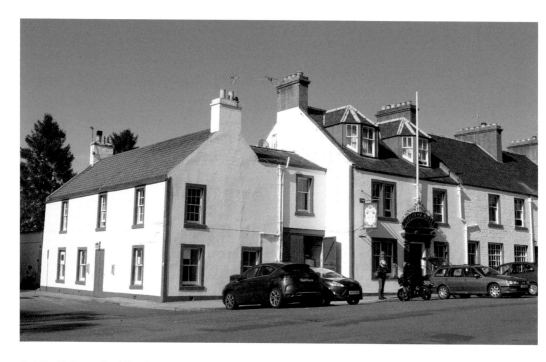

Goblin Ha' Hotel, Gifford

The tale of Goblin Ha' is as magical as its name. During the reign of David I, the barony of Yester was granted to a Norman immigrant – Hugo de Giffard – whose grandson reputedly dabbled in sorcery and was nicknamed 'Wizard of Yester'. In the thirteenth century he built Yester Castle, the hall of which had a vaulted stone ceiling (which is still intact) and was allegedly constructed by an army of hobgoblins.

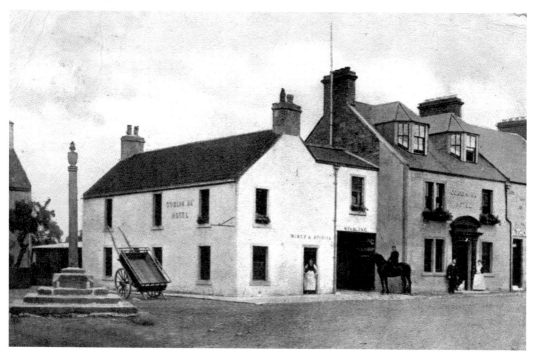

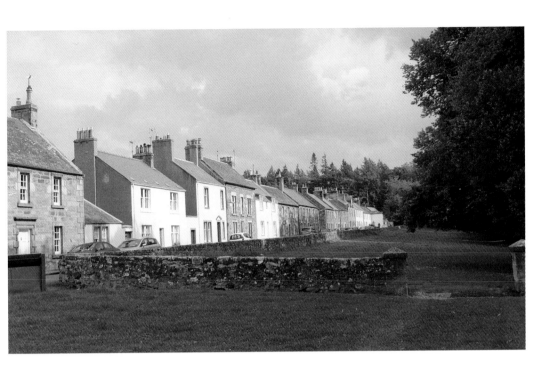

Gifford High Street

The first Yester was thought to be a tower house situated in the wooded glen of Gifford Water, near which was a cluster of bothies, the so-called village of St Bothans. The inhabitants were rehoused in a line of dwellings parallel to the avenue of lime trees that leads to Yester House, and the estate village was renamed Gifford. Meanwhile, the old house was demolished in 1699, and the 2nd Earl of Tweeddale built the mansion we see today.

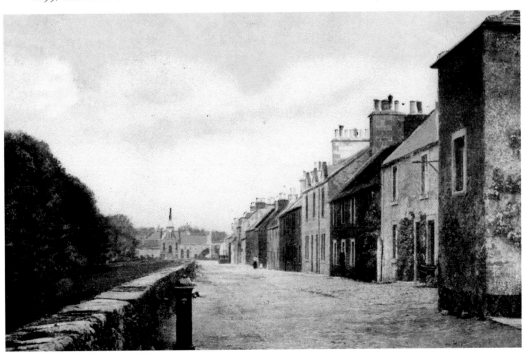

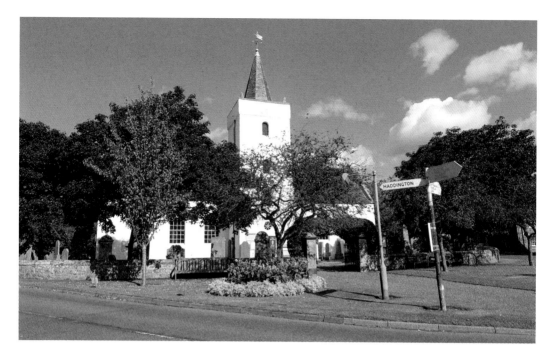

Yester Parish Church

Sometime during the sixteenth century (exact date unknown), a chapel was built near the old village of St Bothans, and continued to be used by the Hay family for burials even after the new parish church was completed in 1710. The church bell certainly, and the pulpit possibly, was brought from the Kirk of Bothans. The white, T-plan church sits in a commanding position at the top of Gifford's main street.

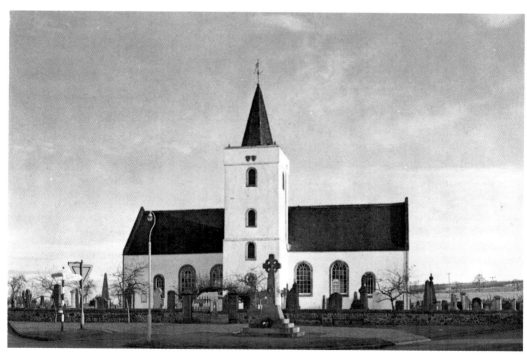

Ford at Biel Mill

Biel House and estate have had a chequered history. The original tower house, owned then by the Earl of Dunbar, was extended, altered and redesigned several times over the centuries by different owners, culminating in the considerable mansion present today. The policies slope down to Biel Water, crossed by a sixteenth-century bridge downstream to the east, and a ford at the mill upstream. In 1948, a serious flood changed the situation and a functional road bridge crosses the water at Biel Mill.

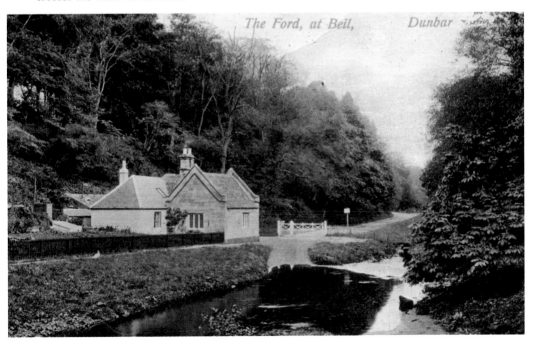

The Ford, at Beil, Dunbar

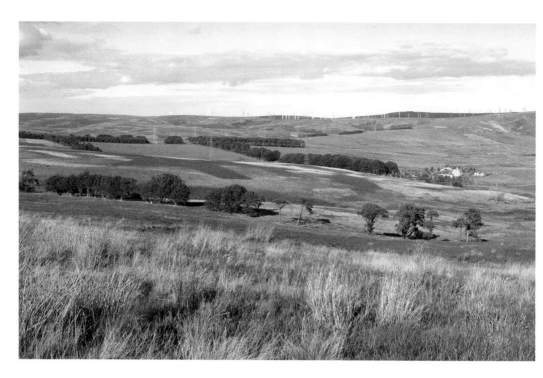

View from the Top of Lammermuir Hills

The gentle moorland slopes form the southern boundary of East Lothian, separating it from the Scottish Borders. Blackface sheep graze the rough grass, red grouse and mountain hares are common, and the mauve carpets of heather are spectacular in August. In the last decade, however, new residents have moved into the hills in the form of wind farms, causing much controversy and the formation of a campaign group called 'Save The Lammermuirs'.

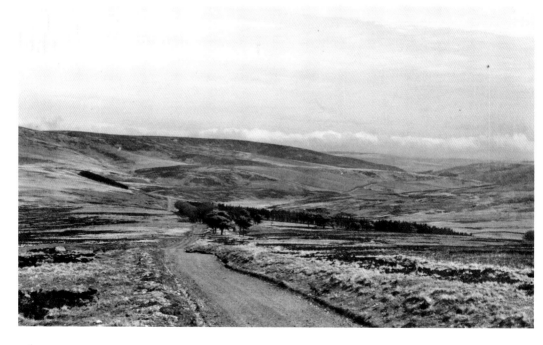

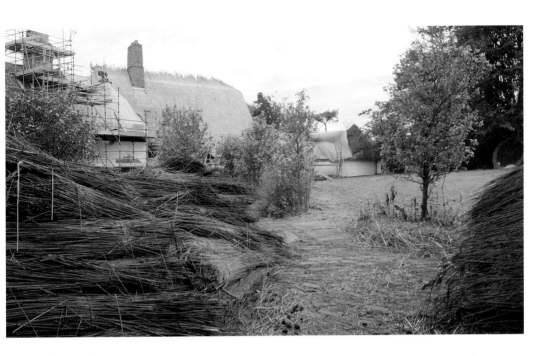

Bolton Muir

In 1930, this most unusual house was built and is described by Historic Scotland as 'a twentieth-century masterpiece'. An article from the local newspaper described it as: 'A Modern Thatched House ... There is being built by Mr Richard Baillie, contractor, Haddington and Pencaitland, on a site on Lennoxlove estate near Inglisfield Toll, a house of unique design. It is of the Old English type, with thatched roof and with interior of the most modern design ... Of striking interest is the thatched roof, which work has been carried out by experts from Norwich.' It is currently being rethatched.

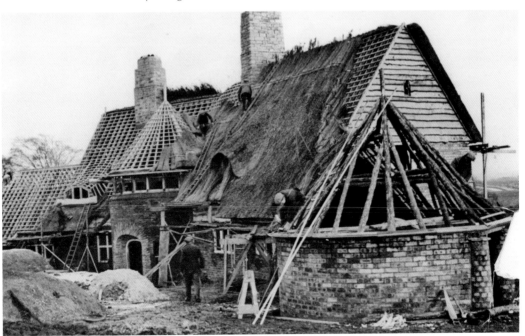

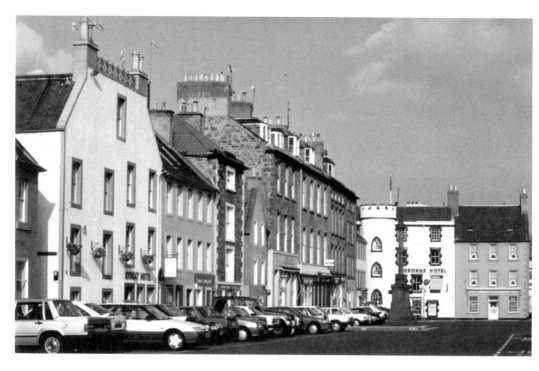

High Street, Haddington, Looking East

The medieval High Street in Haddington was separated from Market Street by an open green area, forming an elongated triangle. The rows of closely packed buildings there now are mostly Georgian and Victorian with a few remnants of earlier structures, but the overall effect is one of colourful and interesting dissimilarity. Pavements were laid on the cobbled street in 1826, and then in 1962 the entire street was improved, the first such project of this nature in Scotland.

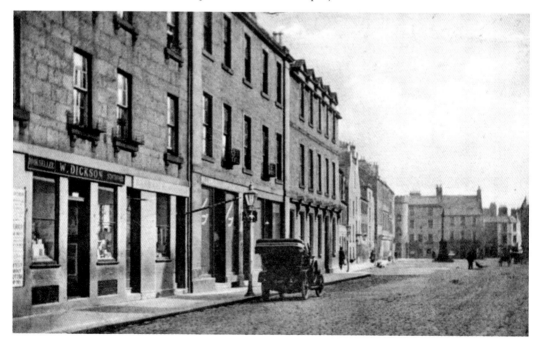

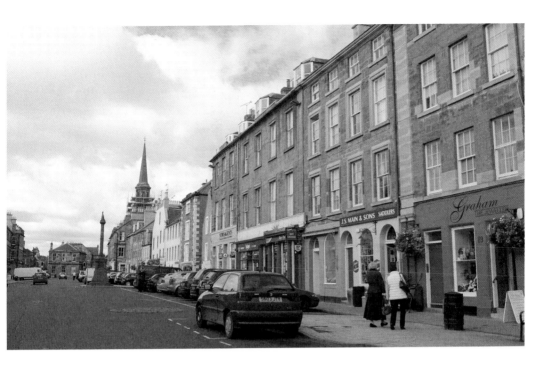

Carriages in Haddington High Street

The spire of the town house soars above the western end of the High Street. William Adam designed the first building, but a courtroom was added in 1788, and the fine steeple replaced an older Dutch-style one in 1831. Carriages taking travellers from Edinburgh to London used Haddington as their first stop to change horses. Various hostelries existed in the High Street, such as the Bluebell Inn (closed 1855), the eighteenth-century Castle Inn (George Hotel), and the Commercial Hotel, run by a character called Deacon-Convener Thomas Muat.

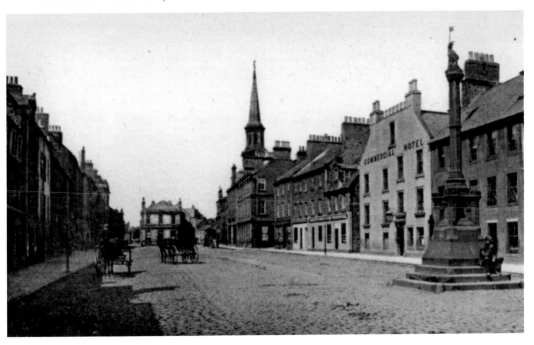

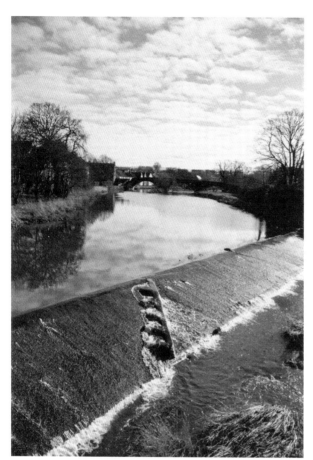

River Tyne from Victoria Bridge
The gentle curve of the River Tyne round St Mary's church to Nungate belies the potential power of the normally modest flow. In 1775, extreme weather caused a 17-foot rise within an hour, badly flooding the town; a plaque marking the water level can be seen in Sidegate. The photograph is taken from the cast-iron Victoria Bridge, which replaced an unsafe wooden construction called Gimmers Mill Bridge.

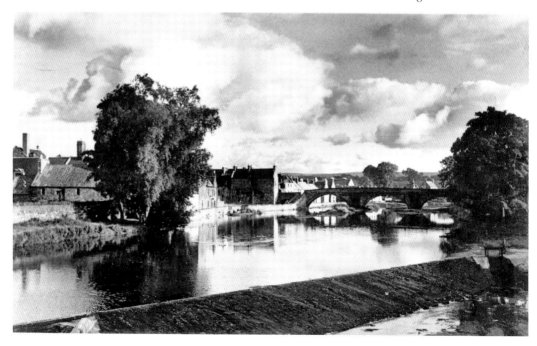

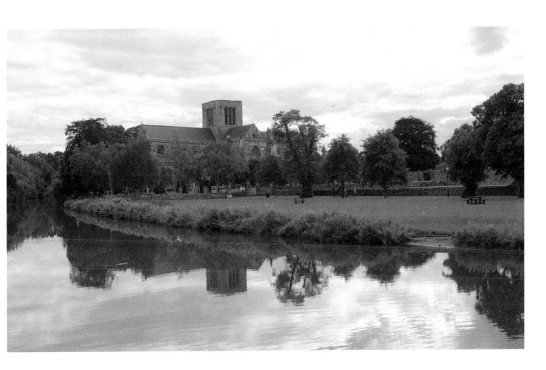

St Mary's Church

This impressive late medieval church, cruciform with a central tower, is actually longer than St Giles' Cathedral in Edinburgh, and may have been topped with a crown spire too. The roof was burned during the Siege of Haddington in 1548, and although it was patched up at various times, the edifice remained roofless until complete restoration 400 years later. It has been given the title 'Lamp of Lothian', which was held by the nearby Francescan monastery in the twelfth century, the light from which was said to be seen from afar.

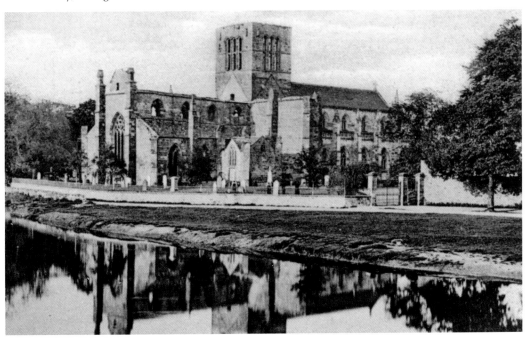

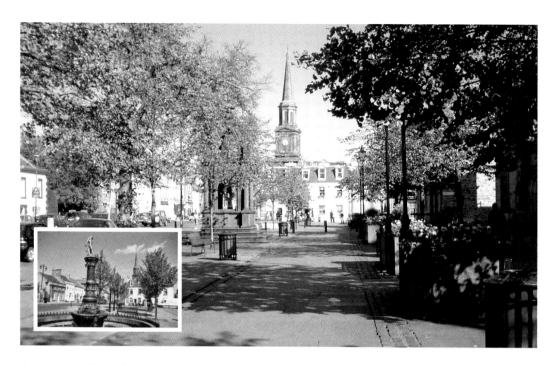

Court Street from the West

Haddington has been a Royal Burgh since the twelfth century. The royal residence was here in Court Street, once called King Street. The site now covered by the County Buildings. Soon after they were built in 1833, a jail was added, which served the county for over 100 years. Next door, the large Corn Exchange (1854) held weekly grain markets. The piazza-like area, embellished with lime trees, a crown-topped monument to the Marquess of Tweeddale and the ornate drinking fountain give Court Street an air of elegance.

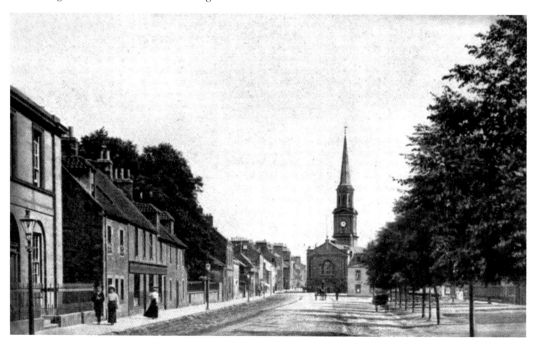

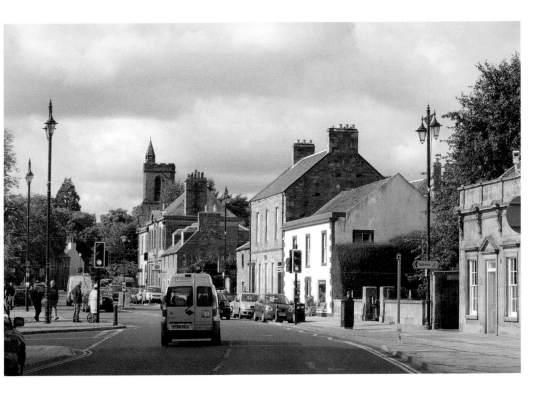

North Side of Court Street

The tower of West church, previously the Free Church, is situated at the West Port, where, in medieval times, the route from Edinburgh entered Haddington High Street. On the corner of Knox Place, opposite, an old pantiled cottage still stands. A variety of nineteenth-century villas grace this side of Court Street, some set back from the road.

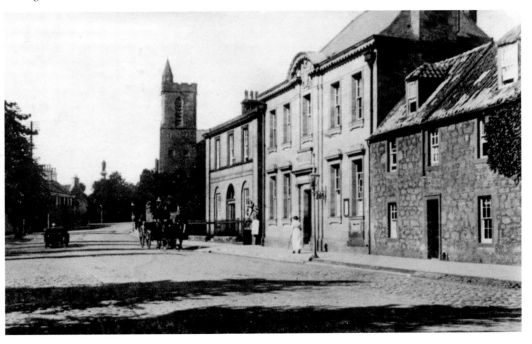

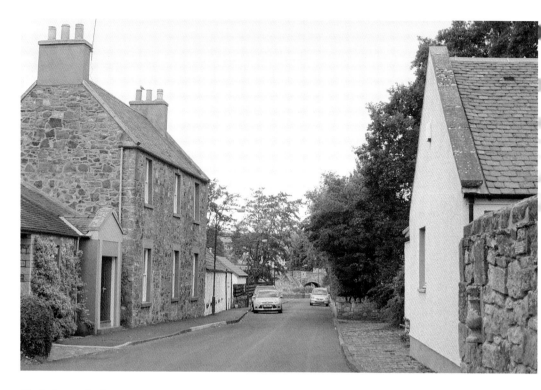

Birthplace of John Knox

Several locations have tried to lay claim to this title but it is now widely acknowledged that he lived in Giffordgate, beside the River Tyne in Haddington. The Protestant reformer (1514–72) was ordained as a Catholic priest, but was influenced by the religious ideals of George Wishart – a Lutheran – and their widespread preaching was to change the course of religion in Scotland.

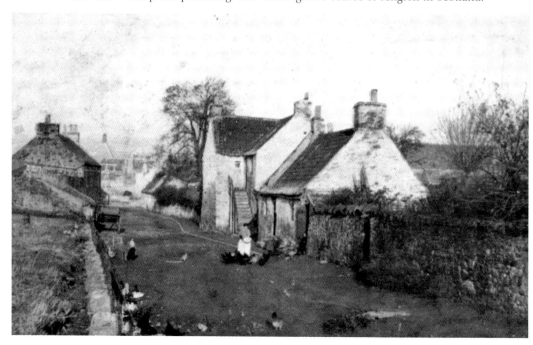

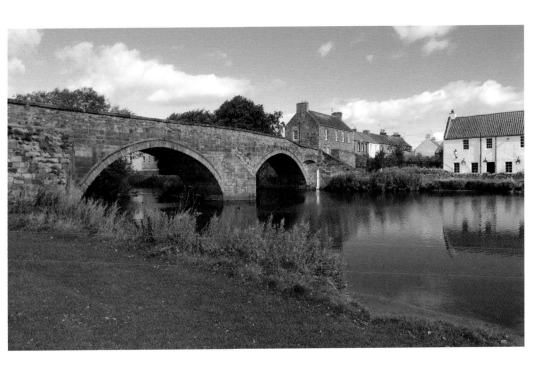

Nungate Bridge
The three-arched bridge across the River Tyne linked wealthy Haddington to the poorer sixteenth-century barony of Nungate. Formerly the road bridge from the east, it is now only used by pedestrians. Something of the character of Nungate is retained by the row of attractive houses parallel to the river (Waterside Bistro) and the cobbled street. On the other side of the bridge, the large green at the Sands was used for a public wash house and drying green during the nineteenth century after an outbreak of cholera.

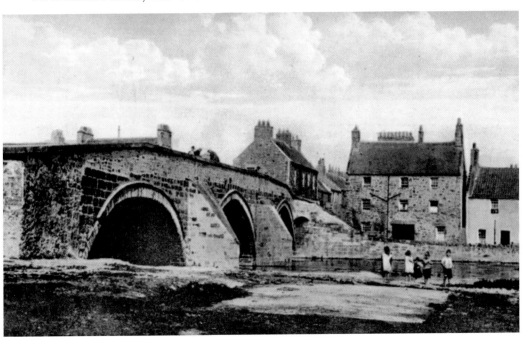

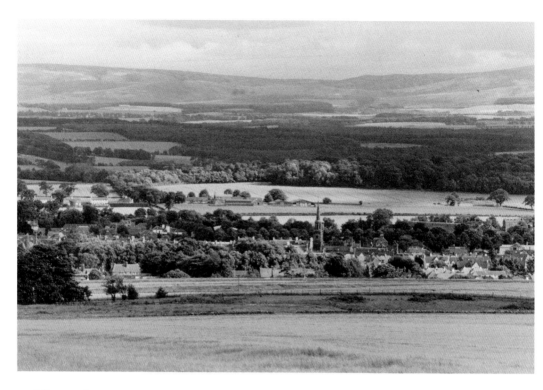

Haddington from the North West

The market town of Haddington is still encircled by fertile fields, albeit this view is no longer visible due to mature trees. Much of the expansion has been along the Edinburgh road to the west, initially with detached Victorian villas, followed by contemporary twentieth-century housing. The A1 road diverted traffic from this route, allowing it to remain a pleasant rural suburb.

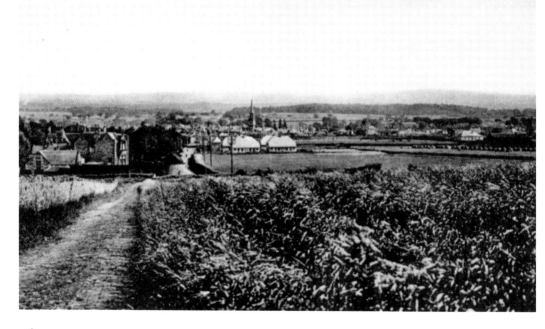

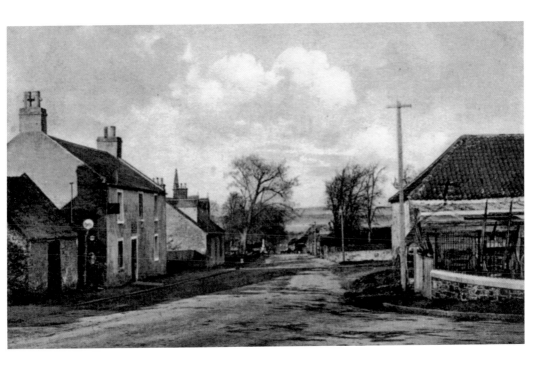

East Saltoun from the Smiddy

The heyday of this village was in the eighteenth century due to agricultural innovations of the Fletcher family, who purchased the Saltoun estate in 1643. The spire of Saltoun parish church dominates the skyline, and was built, along with the manse and school, by John Fletcher Campbell in 1805. There is a granite fountain nearby – a memorial to the family and all they did for the village.

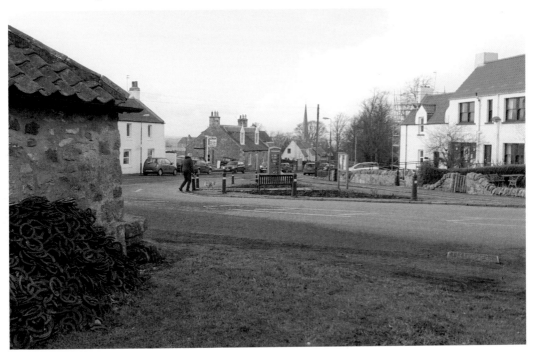

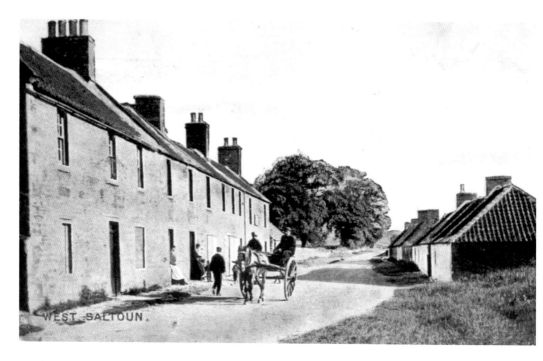

Station Road, West Saltoun

Most of the industries started by the Fletchers were based in West Saltoun around Birns Water, including a paper mill, starch works, the first barley mill (1712), and the bleachfield of British Linen Company in 1750. Nowadays, the village is a quiet community, although nearby Glenkinchie Distillery, the only one surviving in East Lothian, provides some local employment.

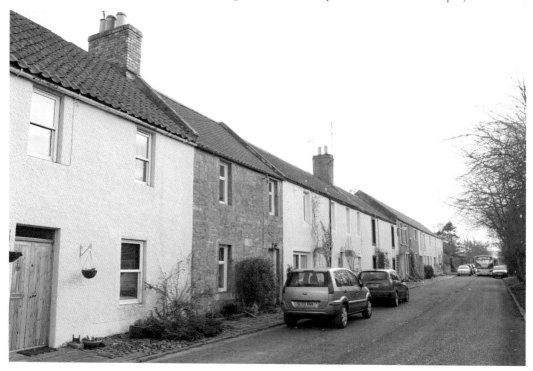

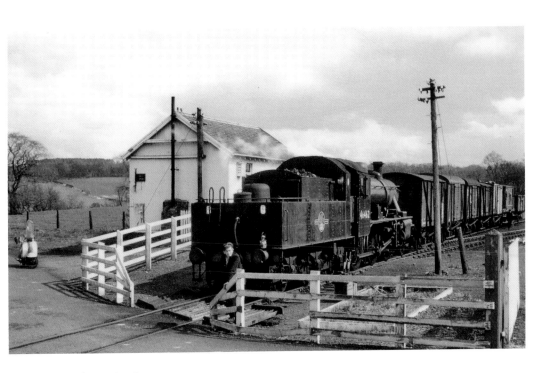

West Saltoun Station
A small railway station existed on the branch line a mile out of the village and was opened in 1901 for carrying coal, agricultural goods and whisky. It was closed to passengers in 1933 due to low usage, but remained open for goods until 1960. The station house has been extended and is a private residence. The trackbed is now used as the route of the Pencaitland Railway Walk.

Holiday Homes, Upper Keith

Humbie is a scattered community lying in the south-westerly fringe of East Lothian, but before the seventeenth century, the parish was divided between Keith Marischal and Keith Hundeby, the Keiths being Grand Marischals of Scotland in the late 1500s. The prominent group of detached cottages were built in 1905 and served as a children's home run by the Church of Scotland.

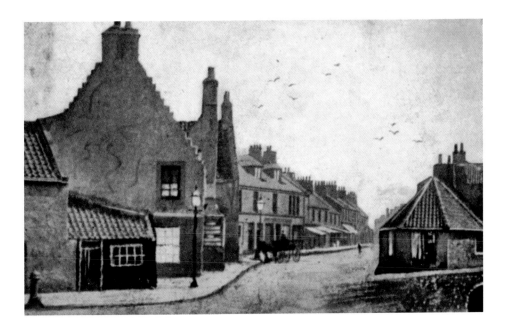

High Street, Tranent

The history of Tranent is based upon the coal seam over which it is built. In the thirteenth century, the monks of Newbattle were granted the coal at Preston in the parish. When deeper mining began, a wooden tramway to Cockenzie was constructed in 1722, succeeded by Scotland's first railway in 1815. There was a major redevelopment at the west end of High Street in 1969, creating a civic square, in which stands a sculpture of one of the victims of the riot against military conscription in 1797, the so-called Massacre of Tranent.

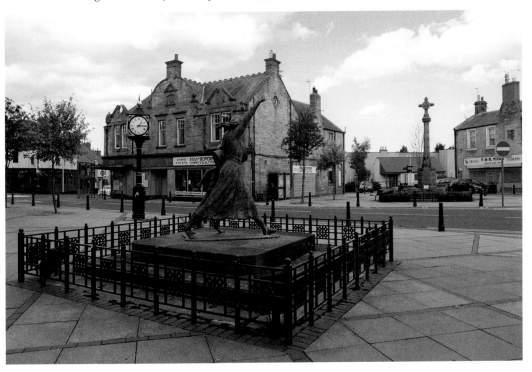

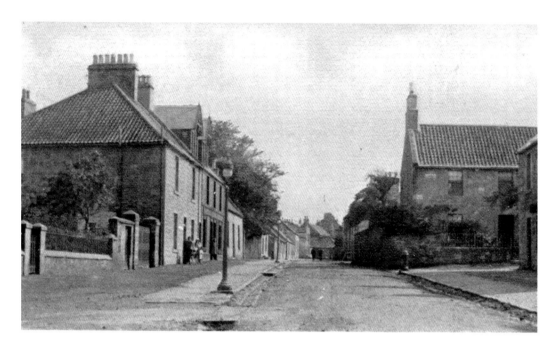

Church Street, Tranent

This street is now a mix of old and modern houses interspersed with empty spaces. The contrast between traditional and contemporary is most apparent in Winton Place, off Church Street, where East Lothian Council's George Johnstone Centre overlooks a ramshackle, pantiled bothy. George Johnstone, a Tranent miner, bravely led fifty of his fellow workers out of a flooded pit in 1929.

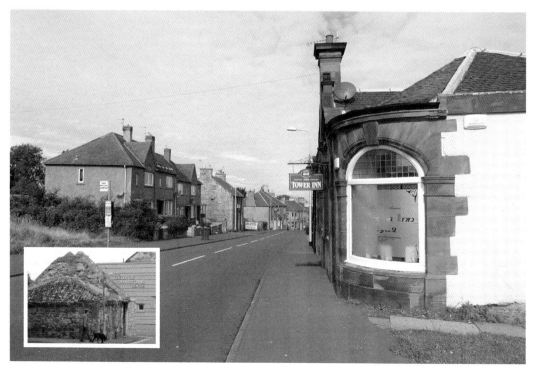

George Street, Ormiston

The history of Ormiston is really a tale of two eras. Between 1735 and 1746, a local landowner, John Cockburn, designed a village to his strict specifications, which included small industries such as brewing, distilling and linen production to provide employment. He overstretched himself financially and had to sell the estate to the Earl of Hopetoun. In the twentieth century, coal mining became the dominant industry and the 'planned' village expanded to the west.

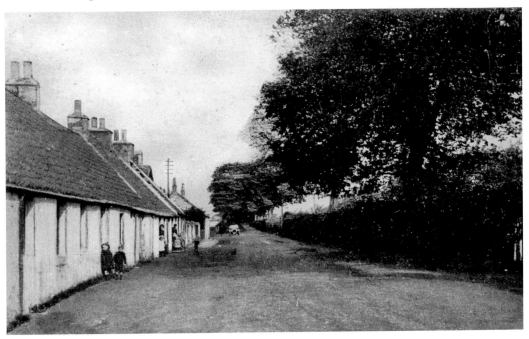

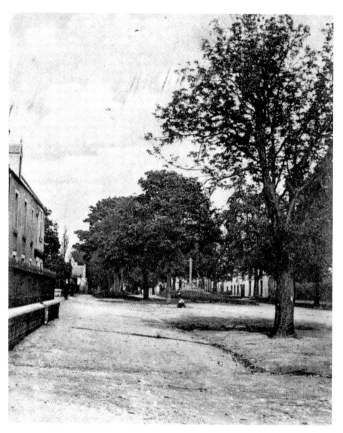

Ormiston Village East
This attractive, tree-lined street was the centrepiece of John Cockburn's planned village. The houses were all two-storey, at his insistence, and divided from the road by wide grass verges. Prior to this, Ormiston was a mere hamlet with a mill at Tyne Water and had no status as a burgh, so it is thought that the mercat cross in the middle of the village (and the road) was imported from elsewhere.

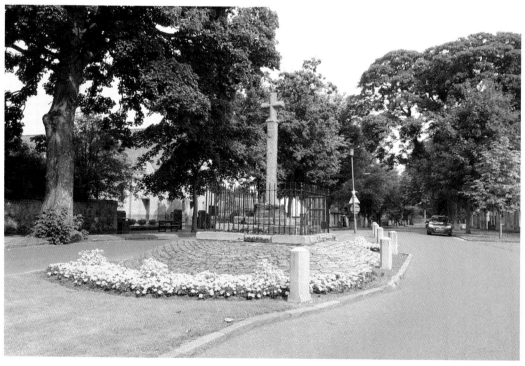

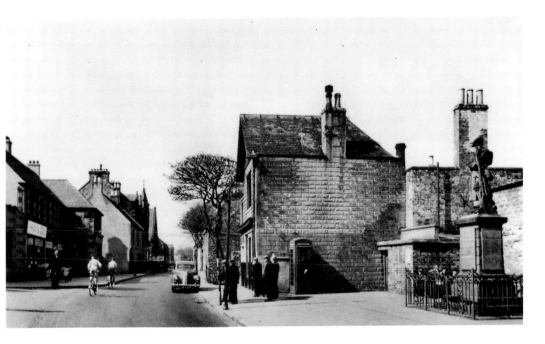

Prestonpans High Street

The parish of Preston had two parts – the coastal Prestonpans, where, as the name suggests, salt panning was the main industry, and Preston, where the markets were held. The splendid seventeenth-century mercat cross, doocot and tower house sit uneasily amid twentith-century housing. The long High Street of Prestonpans has lost many of the old buildings on the seaward side, and the redevelopment has been ad hoc. To the west, it blends into Cuthill, where housing was built for miners working at Prestongrange Colliery. The beam engine now forms part of an industrial museum.

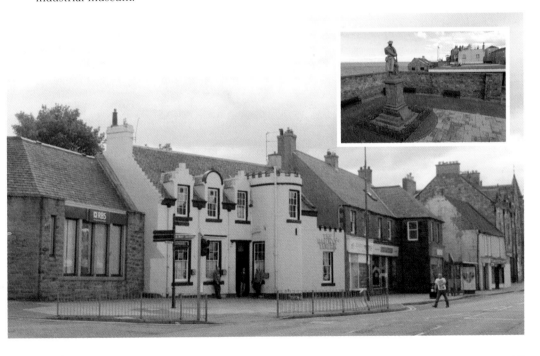

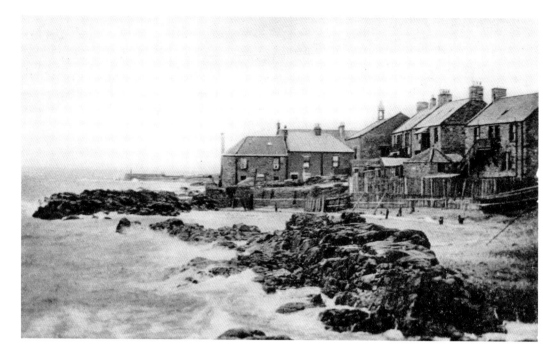

Bell Rocks, Cockenzie

The burgh of Cockenzie, created in 1591 by James VI, has a harbour of its own, despite Port Seton's being less than a mile away. Fishing was important, but coal played a major part in Cockenzie's history. Large quantities of coal from Tranent mines were exported and, in 1835, the coal shipping company of Cadell funded improvements to the harbour. Both these industries declined in the twentieth century, but many of the houses on the seaward side of the High Street retain their character, seen here from the Millennium Garden.

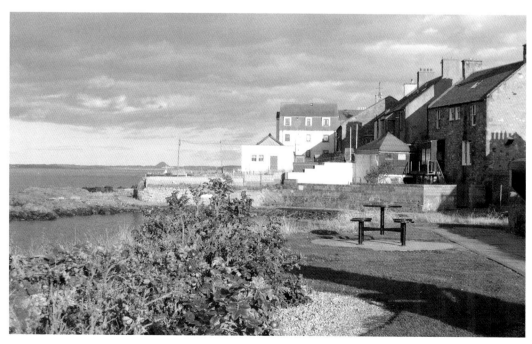

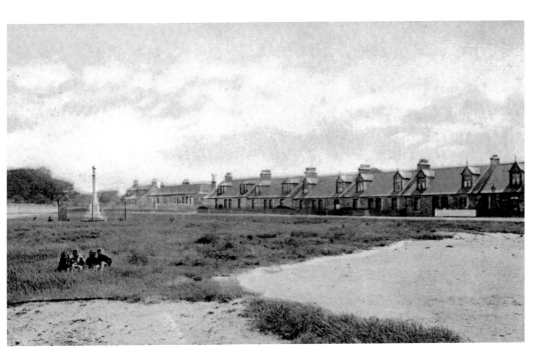

West Green, Cockenzie

As coal mines were closing, the fuel supply was put to use at the Cockenzie power station, built in 1967, extending the contribution the fuel has made to the village, although it has recently been closed, ending another era. The twin chimneys could be seen from all over East Lothian.

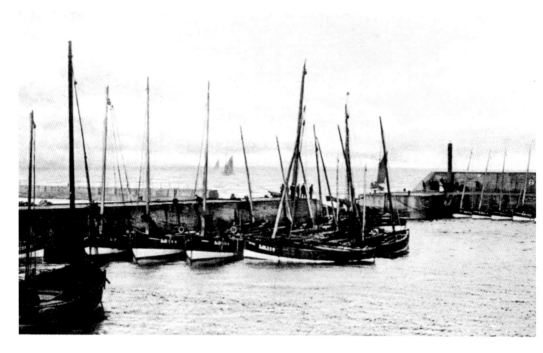

Port Seton Harbour

The Seton family name appears frequently in the area. Lord Seton was responsible for the first harbour in 1655, built for fishing and also to serve the Seton estate. It was extended in 1880 to accommodate larger boats being used during the herring boom. Nowadays, a small fleet fishes for prawns and lobsters. Port Seton has been put on the artistic map by John Bellany, whose work was initially inspired by the lives and hardships of the local fishing community. He died in August 2013.

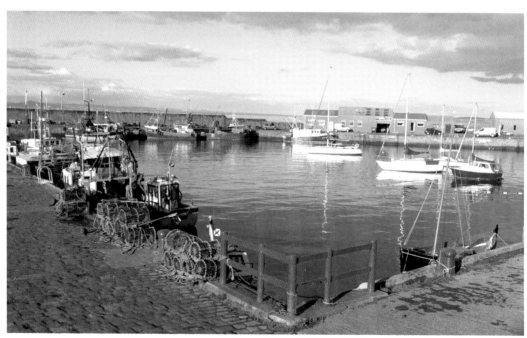

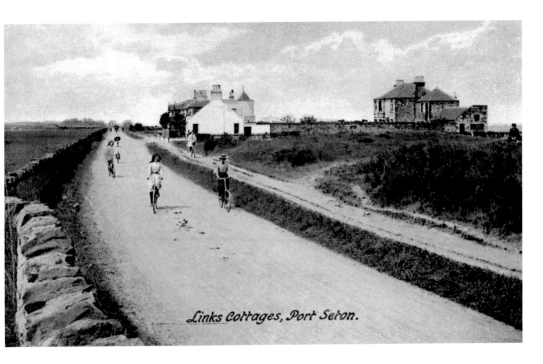

Links Cottages, Port Seton.

Links Cottages, Port Seton
To the east of the village a long stretch of beach (Seton Sands) opens up, which was attractive to urban dwellers who wanted a seaside holiday in the twentieth century. An outdoor swimming pool and adjacent Pond Hall were built in the 1930s at the west end of the links, and a caravan park at the other. In between, the links was used for pitch and put. As tastes changed and holidaymakers travelled further afield, resorts like Port Seton suffered and the Pond Hall was demolished in 1995, replaced by housing.

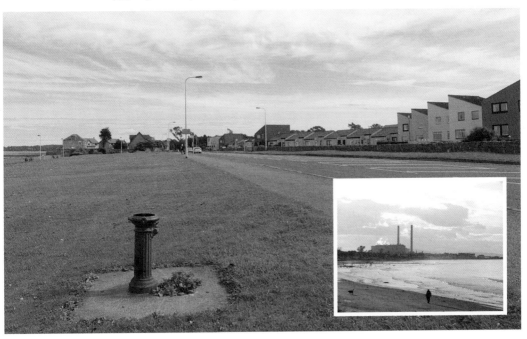

Boys Camping on Boglehill Rocks

Longniddry was a weaving village, but by the mid-nineteenth century it had declined to about 200 souls. It was not until the early twentieth century that new housebuilding started here. This expansion accelerated as Longniddry became a popular place from which to commute to Edinburgh. A golf course was created in 1921 between the coast and village, which necessitated clearing trees from Boglehill Wood, a place said to be associated with witchcraft. The old postcard is dated 1915 when Boglehill must have been an exciting place for boys to put up a tent!

Gosford House Grounds

This estate was purchased by the Earl of Wemyss in 1784, and by 1800, a new Gosford House was built, designed by Robert Adam. The side pavilions were extended in 1890. The policies stretch across 5,000 acres on the land between Longniddry and Aberlady, and have been recently restored. Gosford bothy farm shop, at the east end of the estate, sells local produce, much of it organic.

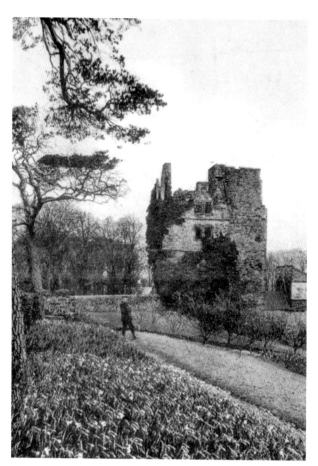

Redhouse Castle, Longniddry

The ruin of this sixteenth-century tower house looms above the road and railway east of Longniddry. It was built by John Laing, Keeper of the Royal Signet, and then passed to the Hamilton family through marriage, but it was forfeited in 1746 after the Jacobite rebellion. It was bought by Lord Elibank, but never again inhabited, so it quickly fell into disrepair. The grounds have been used as a market garden for forty years and a new garden centre was opened in March 2013, with an imposing backdrop!

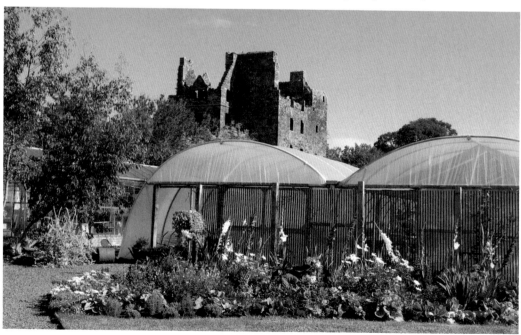

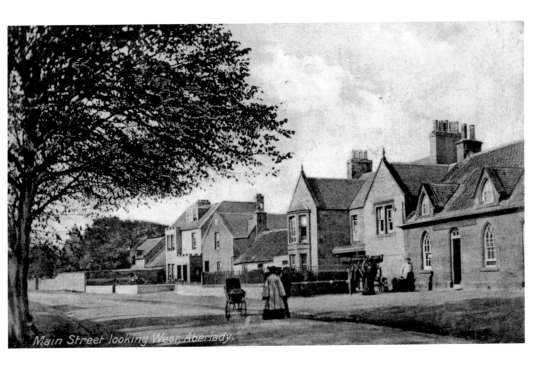

Main Street looking West, Aberlady.

Main Street, Aberlady

The first building in view when entering Aberlady from the west is the parish church of 1886 with a fifteenth-century tower and loupin' on stane on the pavement outside. The subsequent cottages are unusual – one is a long, single-storey building with ten front doors and Gothic-style windows, favoured by the Earl of Wemyss who built them. Outside Cross Cottage is a pedestal topped with the stump of the ancient Aberlady Cross. The local conservation and historical society erected a reconstruction of the eighth-century Northumbrian cross next to the church in 2011 (*see inset*).

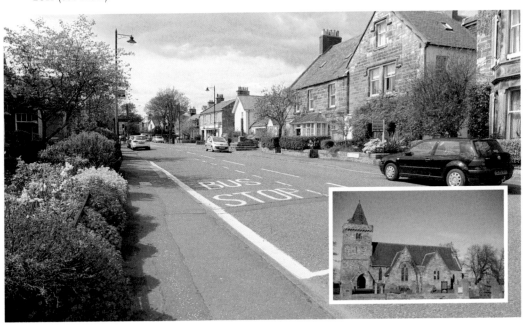

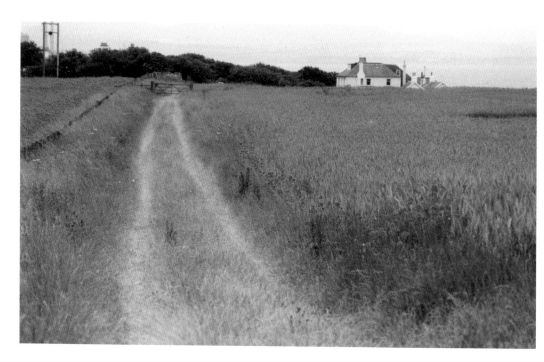

Craigielaw

The photograph of the wheatfield at Craigielaw Farm was only taken twenty years ago, but it has since been transformed into an exclusive estate of luxury houses with stunning panoramas across the Firth of Forth to Fife and beyond. The white house in the distance is Green Craig, a secluded hotel at Craigielaw Point.

Craigielaw Farm Building

Steading conversions are widespread in East Lothian, and make appealing dwellings. This one has been a spectacular metamorphosis to Craigielaw Golf Club, opened in 2001, together with an 18-hole championship links course. Golf and associated tourism is very important to the economy of East Lothian.

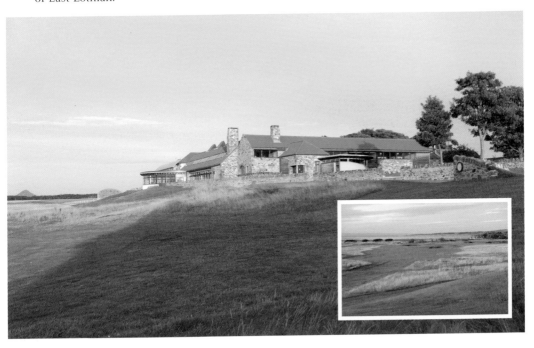

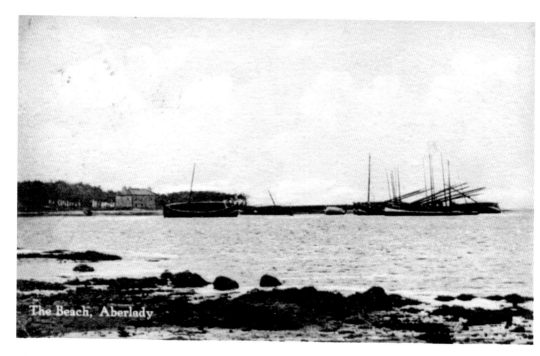

The Beach, Aberlady

Aberlady Bay

It is difficult to imagine the silted estuary of Peffer Burn today as the medieval harbour that it once was. Known as the Port of Haddington, high tides were necessary for entry and trade was never significant, unlike smuggling, which was said to be rife. The skeletons of wooden boats can be seen along the salt marsh, acting as proof of past navigation in the bay. The eastern side of the bay is Britain's first Local Nature Reserve (1952 designation), particularly noted for its birds and flowers.

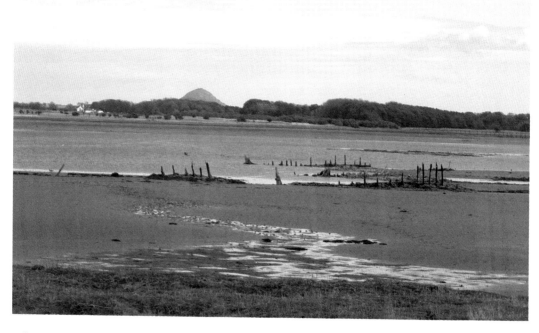

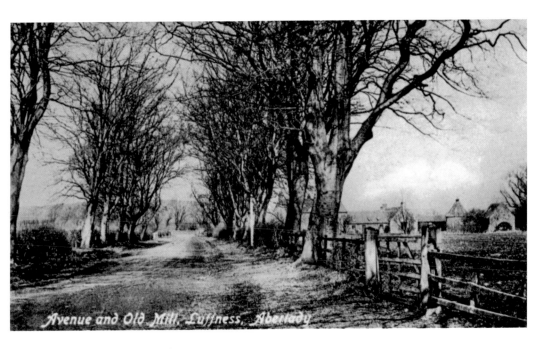

Avenue and Old Mill, Luffness, Aberlady

Avenue and Old Mill, Luffness

The prime position of the present Luffness Castle, overlooking Aberlady Bay and owned by the Hope family for 300 years, was occupied by a Carmelite friary and a castle in the thirteenth century. The core of the present house was built in 1584 by Sir Patrick Hepburn, and sold in 1739, after which it was extended several times. The mill cottages, close to Peffer Burn, are still occupied, but the kiln roof has lost its pantiles in recent years. Across Timmer Brig is Luffness Golf Course, and it is said that the southern wall of the old clubhouse was camouflaged so the view from the castle was unspoilt.

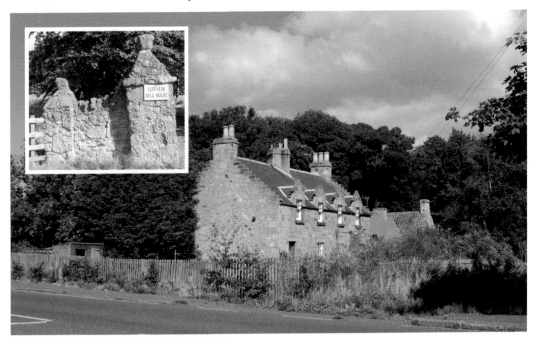

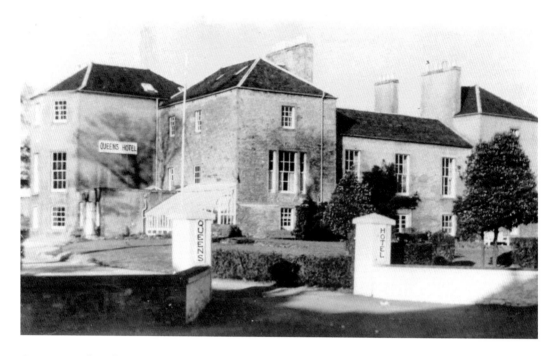

Queens Hotel, Gullane

This property has undergone a few name changes, the first one being Gullane Lodge. In 1928, it became Queens Hotel but, when sold in the 1990s, it was renamed Templar Lodge, so called because it was erroneously thought to have been the site of a Templar castle. The building is currently being converted to apartments, now called St Andrews Court. There are some notable twentieth-century plasterwork friezes inside.

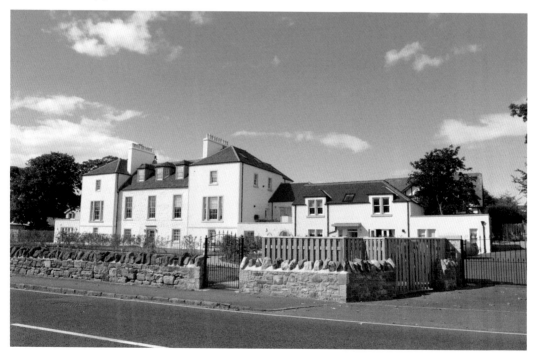

West Bents, Gullane

The sand dunes (bents) surrounding the beautiful Gullane Bay have become covered with dense hedges of Sea Buckthorn, the orange berries of which add a layer of colour to the panorama. The vegetation also helps to prevent sand from being blown inland; in 1612, storms inundated the Norman parish church of St Andrew with sand, resulting in it being abandoned, and the congregation attended Direlton thereafter. This viewpoint was a magnet to wealthy people from Edinburgh, who began to build large villas on the slope of Gullane Hill from the late nineteenth century.

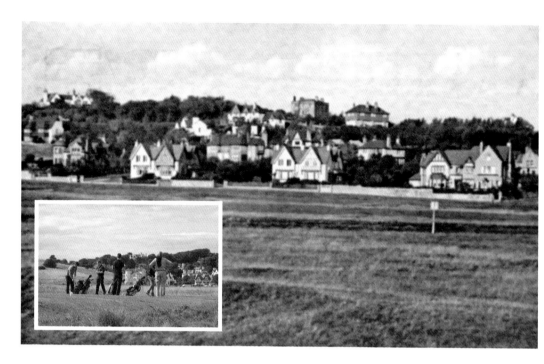

West End of Gullane

The name of Gullane is synonymous with the game of golf, primarily due to Muirfield being an Open Golf Championship course. However, there are four further courses – Luffness and three for Gullane Golf Club – all founded between 1884 and 1910, although the game was first played on the links about 300 years ago. Since the black-and-white photograph was taken, a pro shop and visitors' clubhouse have been built at the foot of West Links Road and next to the 18th green respectively. The original clubhouse is of modest proportions.

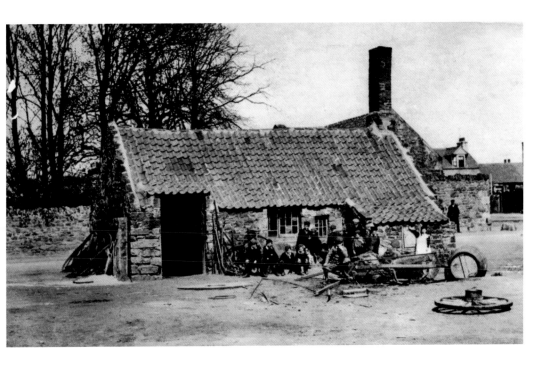

The Smiddy, Goose Green

During the nineteenth century, Gullane was known for training racehorses and nicknamed 'Newmarket of the North'. In particular, George Dawson, whose training stables were at Stamford Hall, Goose Green, together with four of his sons, became the most successful horse racing family in Britain. The smiddy will have been well used at that time. The building is still used, but as a gift shop called The Old Smiddy.

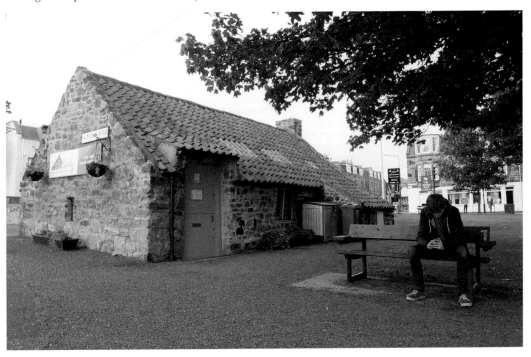

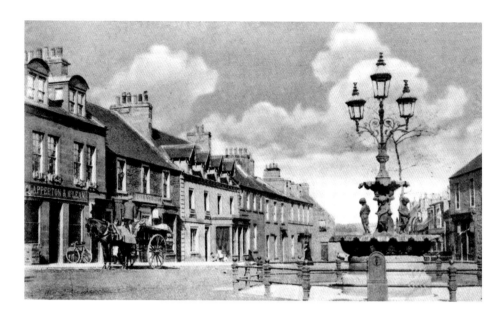

Fountain, East Linton

The heart of East Linton is its charming square, in the centre of which sits a cast-iron fountain, presented to the village in 1882 by John Drysdale. The houses surrounding this centrepiece are attractive, mostly eighteenth-century at the southern end. Peeping above this roofscape is the distinctive spire of St Andrew (formerly the Free Church), while the thirteenth-century Prestonkirk parish church sits on a hillock site thought to be associated with St Baldred.

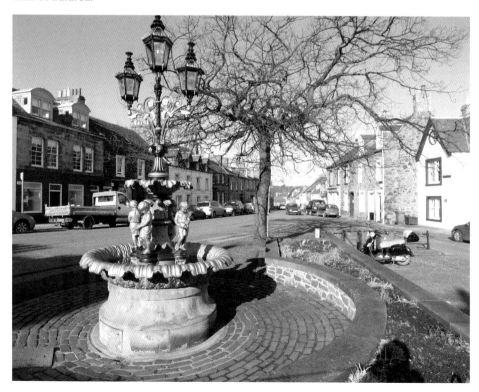

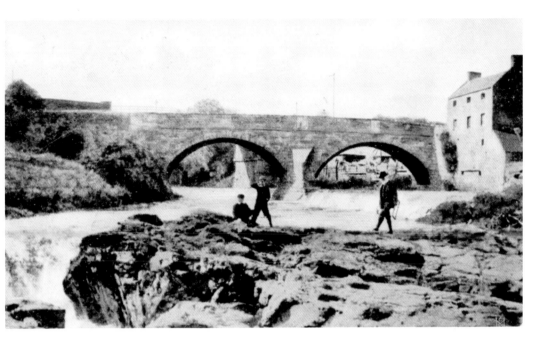

Old Bridge, East Linton

Below the two arches of the sixteenth-century bridge, the River Tyne rushes through rocky falls or linns, after which the village name was derived. The Old North Road used to cross over it, so the opening of the A1 has helped its preservation. The prefix 'East' was added to differentiate it from West Linton in Peeblesshire. During the agricultural revolution of the eighteenth century, East Linton was an important centre for milling and horticulture, and home to a number of pioneers of agricultural improvement, notably Andrew Meikle.

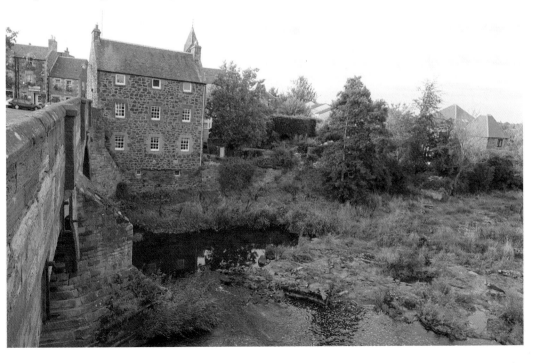

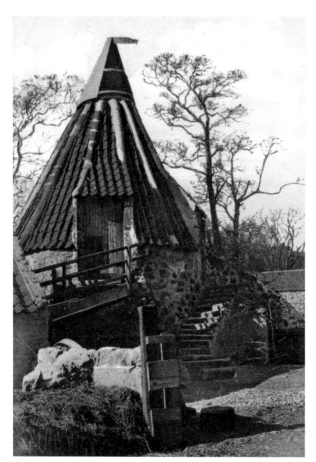

Preston Mill

The course of the River Tyne has an abundance of mills, but the aesthetically pleasing Preston Mill is known to photographers and artists alike. Milling has taken place here since the sixteenth century, but the present stone buildings are eighteenth-century, and commercial oatmeal production only ceased in 1959. It was gifted to the nation by George Gray of nearby Smeaton, and is managed by the National Trust for Scotland.

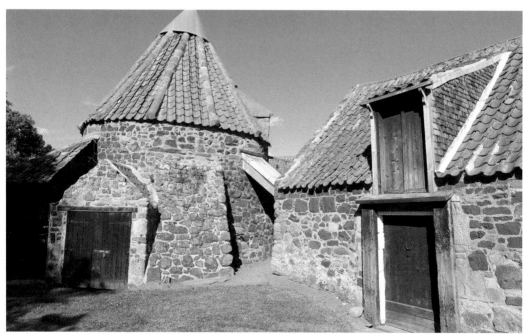

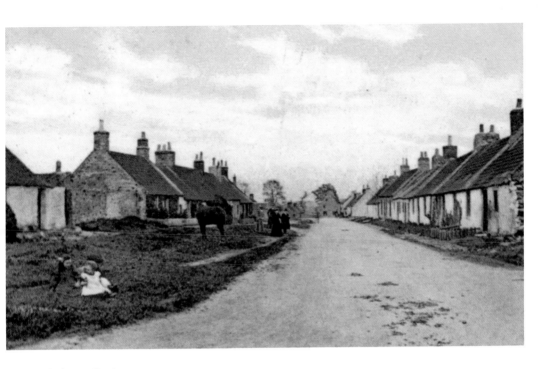

Athelstaneford

The name is said to come from the killing of Northumbrian Athelstane by Angus MacFergus, King of the Picts, during a battle in the ninth century on this ridge. Purportedly, a vision of a cross was seen in the sky, which became the basis for the Saltire, the flag of Scotland. The Flag Heritage Exhibition is now housed in the 1583 lectern doocot beside the parish church. Home House, the oldest in the village, is early eighteenth-century, whereas the delightful single-storey cottages were built a century later.

Fenton Tower, Kingston

The hamlet of Kingston is situated in an elevated position a few miles south of North Berwick. Fenton Tower sits on top of a hillock, commanding views in every direction – a good reason in the sixteenth century to erect a tower house. It was built for Sir John Carmichael, appointed by James VI to watch for English incursions into East Lothian. It lay in a ruinous state for many years, but was restored and transformed into a hotel, which opened in 2002.

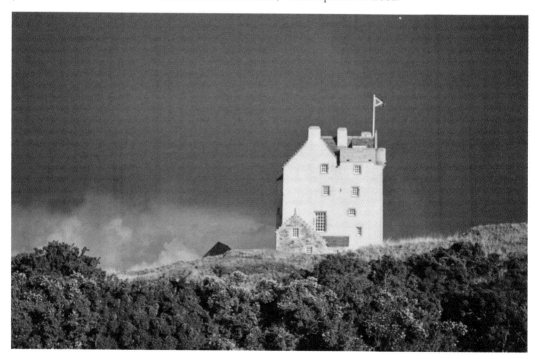

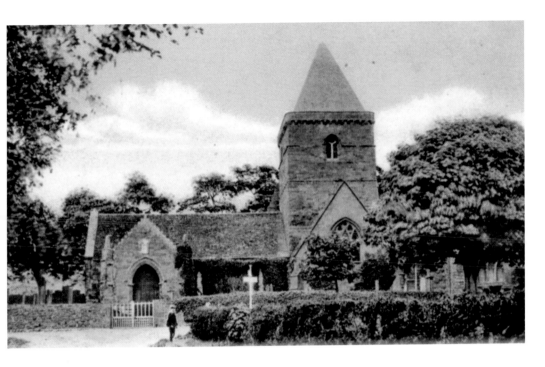

Whitekirk

This church has a varied and interesting history, beginning in the twelfth century as a simple parish church. Then, around 1300, an era of pilgrimage began, and was to continue until 1537. Thousands of visitors flocked to the local well, believing the water could perform healing miracles, and hostels were built to accommodate the pilgrims. Thereafter, it reverted to a parochial kirk, but was damaged by suffragettes in 1914. It has been beautifully restored to the magnificence seen today.

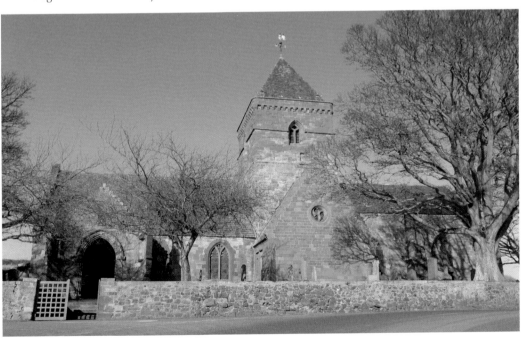

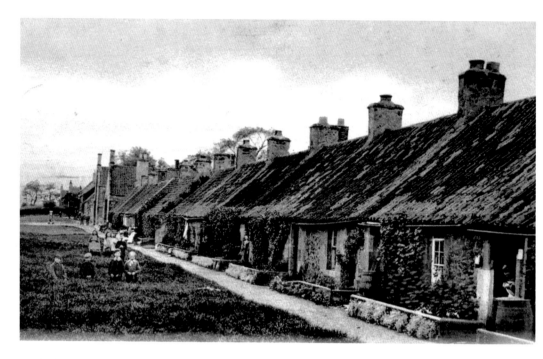

Tyninghame Cottages

The name means 'hamlet on the Tyne', whose estuary is a mile away from this estate village. The original church was founded by St Baldred, who died in 756, and the remnants of a later twelfth-century chapel still exist in the grounds of Tyninghame House. In 1761, the Earl of Haddington cleared the village, and moved it to where it is today in order to plant up the policies of his mansion. The resulting gardens, holly hedges and woodlands are renowned for their beauty and tranquillity.

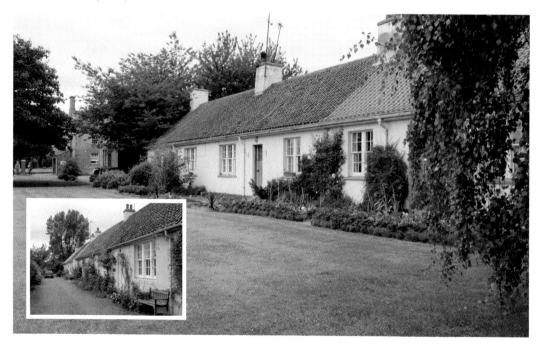

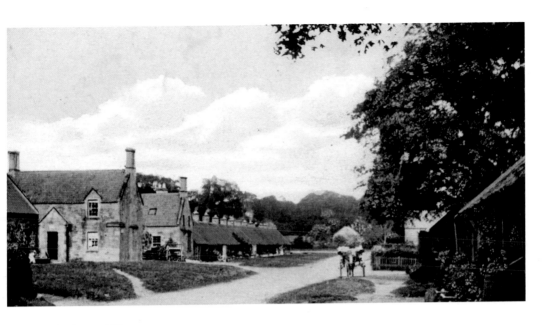

Tyninghame Village

The relocated village of Tyninghame was provided with all amenities: a school, an inn, a bakehouse and a sawmill, as well as rows of cottages. A lot of these were built in early nineteenth century and are now listed buildings, although the community is an active one and the street feels alive. The old smithy is used as a tea room, attracting walkers from the John Muir Way and Ravensheugh Sands.

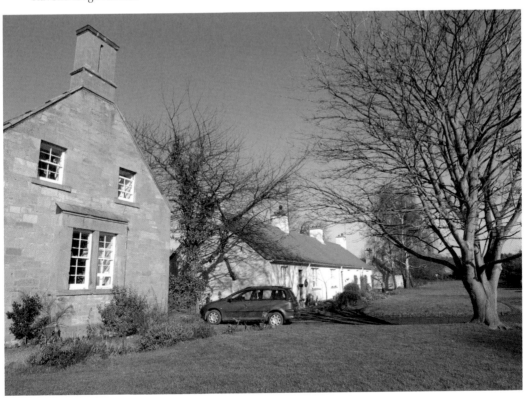

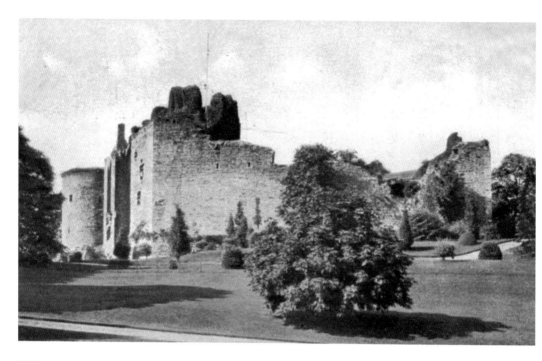

Dirleton Castle

The Norman family of De Vaux were given the barony of Dirleton in the twelfth century by David I, and erected the castle (c. 1240) on a rocky outcrop. During the First War of Scottish Independence in 1298, it was badly damaged but eventually repaired by the Halliburton, after which the Ruthven family acquired the fortification. In 1650, Cromwell inflicted more damage, but the Nisbet family, who lived at Archerfield, took over the castle and gardens, gifting it to the nation in 1923. Historic Scotland now manage it.

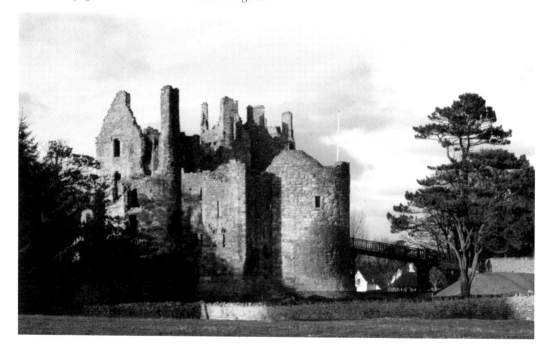

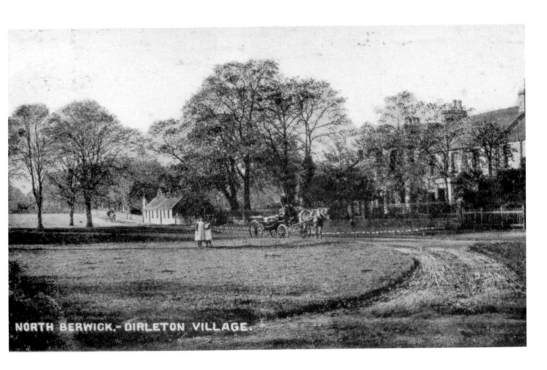

NORTH BERWICK.- DIRLETON VILLAGE.

Dirleton Village

The centrepiece of the hamlet is the expansive village green, disproportionate to the number of buildings surrounding it, and since the bypass took away a lot of traffic, there is an air of quietude to Dirleton. The parish church is tucked away in the north-west corner, and was built shortly after Gullane parish was transferred to Dirleton in 1612.

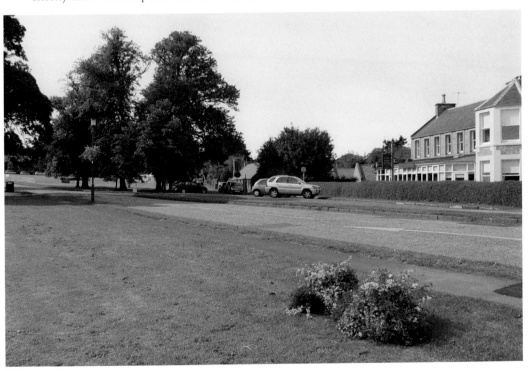

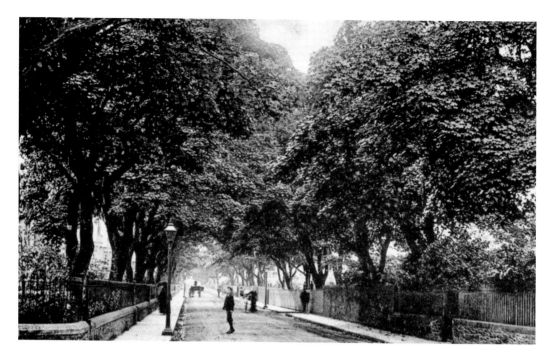

Dirleton Avenue, North Berwick

People had been visiting North Berwick for centuries, but most of them arrived by ferry. All this was to change in 1848, when the railway came to the town; it was a branch line of North British Railway's Edinburgh to Berwick route. The soaring popularity of North Berwick as a resort resulted in new villas being built by the Victorian and Edwardian middle classes – Dirleton Avenue is lined with them. One hundred years ago, pedestrians would have enjoyed a pleasant stroll along the tree-lined street to the beach, but the narrow pavements and modern-day traffic are not conducive to that now.

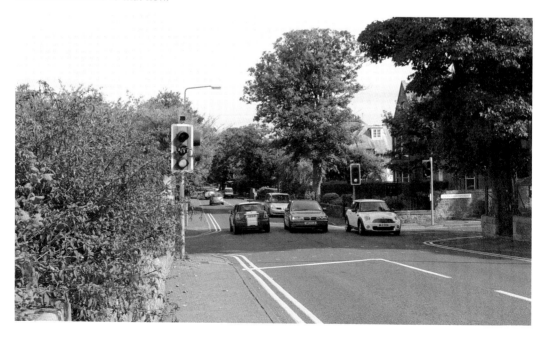

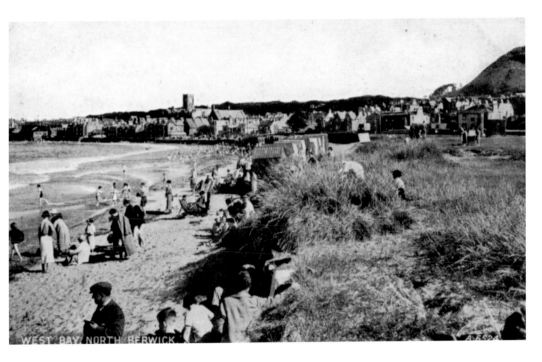

North Berwick Bay

The climate in this area is known to be the driest and sunniest in Scotland, albeit often breezy, making North Berwick Bay a busy destination for a seaside holiday, particularly in the first half of last century. Beach huts, seen in the old picture, were part of that culture, but are rarely seen in Scotland now; Coldingham in Berwickshire is a notable exception. There were a large number along Gullane Beach but a storm wrecked the majority in 1953.

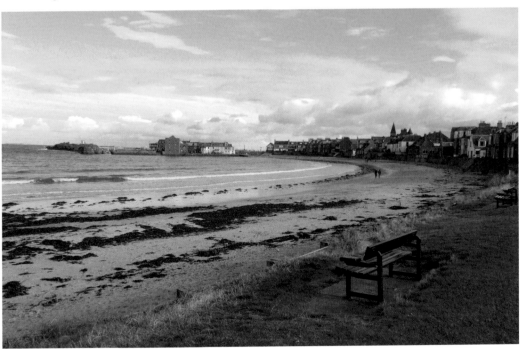

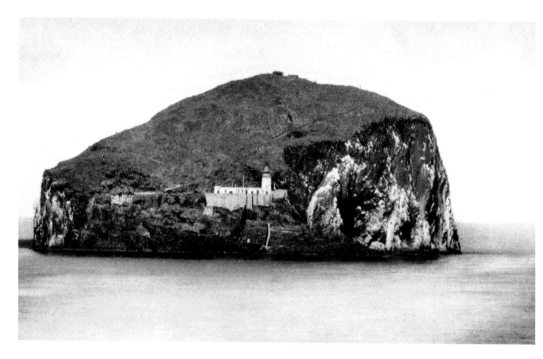

Bass Rock

A unique landmark, this 313-foot high volcanic plug, usually whitened by guano from 150,000 gannets, has a lot of history for such a small rock. St Baldred was a hermit here in the eighth century, and the ruins of a pre-Reformation chapel sit on the site of his cell. In 1316, the Lauder family took ownership of Bass and constructed a fortress on the landward slope. This was used as a prison for Covenanters in the 1600s, and later for Jacobites. Sir Hew Dalrymple purchased it in 1706, five years after the fort was demolished. The lighthouse was built in 1901.

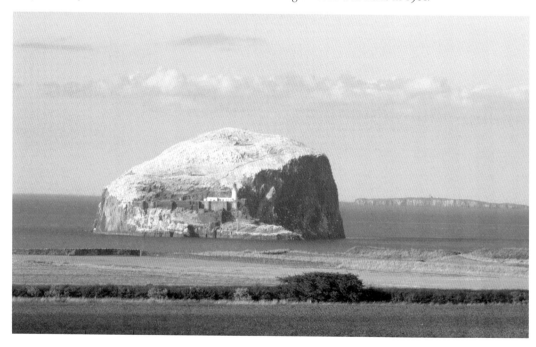

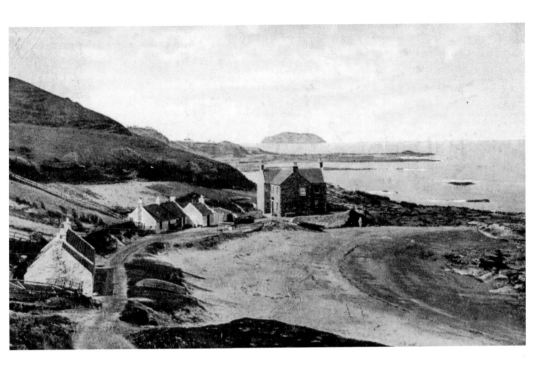

Canty Bay

This little gem, hidden away between Tantallon Castle and North Berwick, was once a fishing hamlet. Bass Rock was tenanted in the eighteenth century for grazing sheep (7 acres) and harvesting gannets, known then as Solan geese, the latter being sold both at the bay and in Edinburgh markets. The cottage where the birds were plucked is called 'Feather House'. The enterprising tenant also ran an inn on the clifftop and ferried visitors to Bass Rock. Canty Bay Hotel is still in business and the houses in the bay are owned by a Christian scout trust.

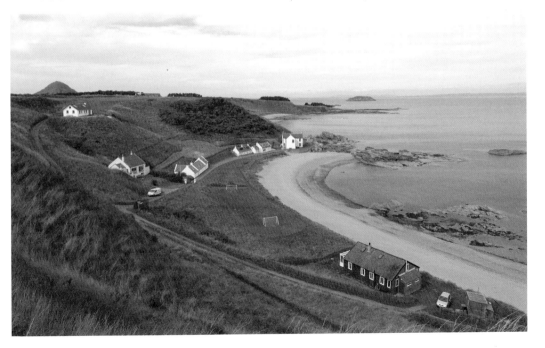

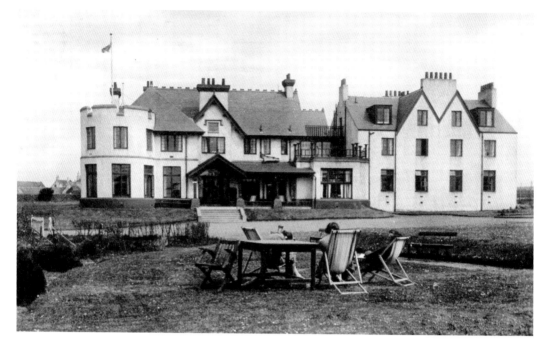

Tantallon Hall

This was a striking edifice in its short life, sitting in a prominent place on top of the cliff overlooking the west bay. In 1894, as more tourists flocked to North Berwick, a second golf course was created and Tantallon Hotel was built in 1907 to accommodate the players. The First World War intervened and the hotel was used to billet soldiers, leaving the premises degraded, and the Tantallon Company went into liquidation in 1917. Subsequently, it was taken over by Friendship Holidays Association and then considered as the clubhouse for Glen Golf Club, but this proved financially unviable. It was demolished in 1965 and replaced with housing.

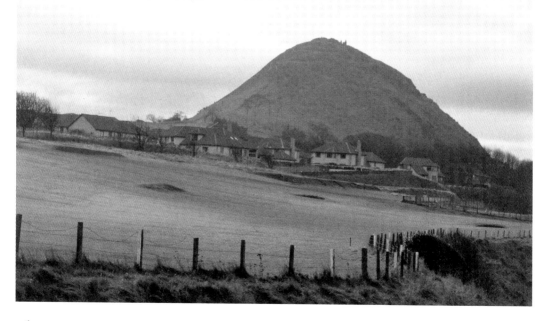

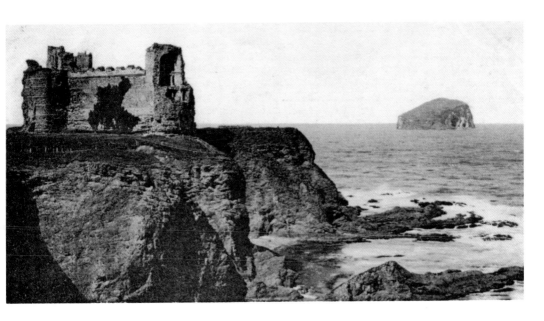

Tantallon Castle

Built by the powerful Douglas family – the Earls of Angus – in 1350, it is described in 'Marmion' by Sir Walter Scott: 'Tantallon vast/Broad, massive, high, and stretching far,/And held impregnable in war,/On a projecting rock they rose,/And round three sides the ocean flows,/The fourth did battled walls enclose,/And double mound and fosse,/By narrow drawbridge, outworks strong,/Through studded gates, an entrance long,/To the main court they cross.'

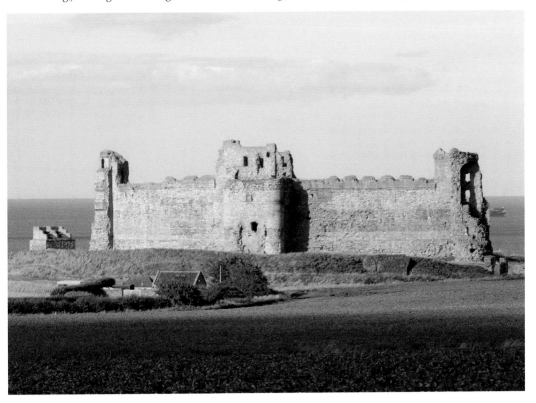

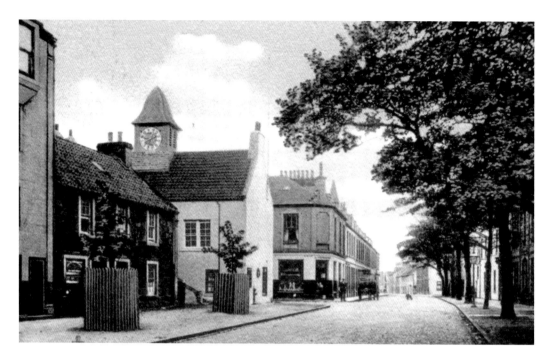

Quality Street, North Berwick

Robert III granted the original charter of Royal Burgh to North Berwick in 1373, and this was confirmed by James IV in 1568. At this time, Quality Street was named Trongait and the southern end of it was named Common Square. The Dalrymple family acquired North Berwick estates, which included Bass Rock, in 1692. Their ancestral home was Leuchie House but the town residence was The Lodge, just off Quality Street, now the oldest inhabited house in the burgh. The gardens were sold to North Berwick Town Council in 1939 and are open to the public.

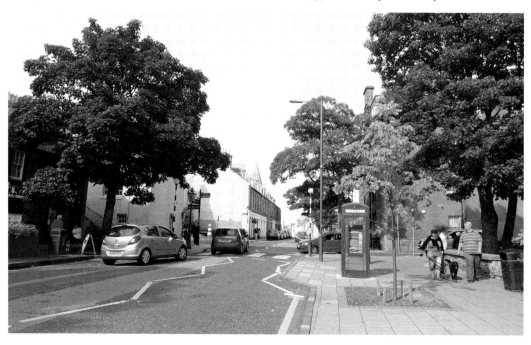

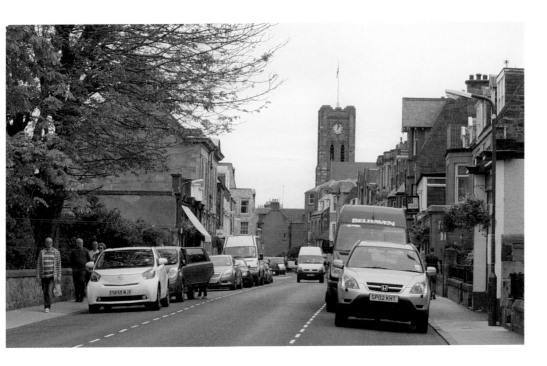

High Street, Looking East

The parish church, with its landmark tower, is the third one in North Berwick, built on the site of the manse of the second church. The original (*c.* 1170) was a small affair sitting on an island that was accessible on foot at low tide. Over time, the shoreline changed and erosion caused this site to be abandoned in 1650, although some ruins can still be seen by the Scottish Seabird Centre. For the next 200 years, the church was in Kirk Ports. The parish is now named St Andrews Blackadder to commemorate John Blackadder, covenanter and minister, who died while imprisoned on Bass Rock for his beliefs.

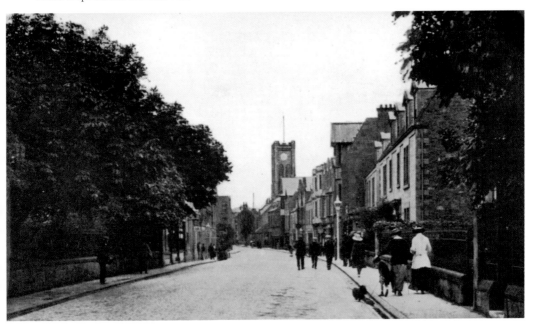

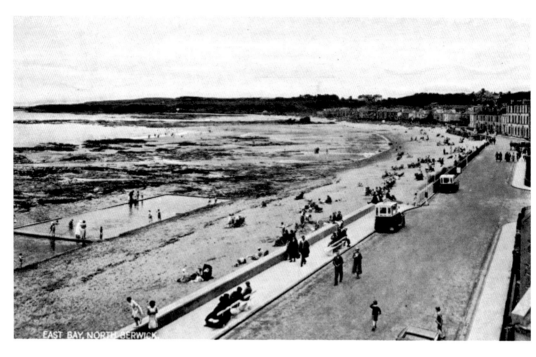

East Bay, North Berwick

The game of golf, so important to the economy of East Lothian, has been played here since the early seventeenth century; records from 1611 show that two locals had to apologise to the church for playing on the Sabbath. North Berwick Golf Club was founded in 1832. The course was on the west links, but prior to 1790, winter golf was on the east links behind this bay. The Glen Golf Club has been here since 1906, with Bass Rock overlooking all 18 holes.

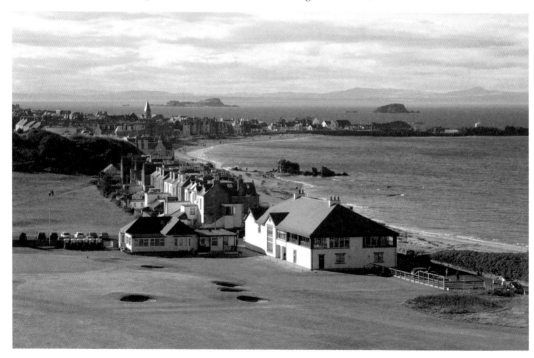

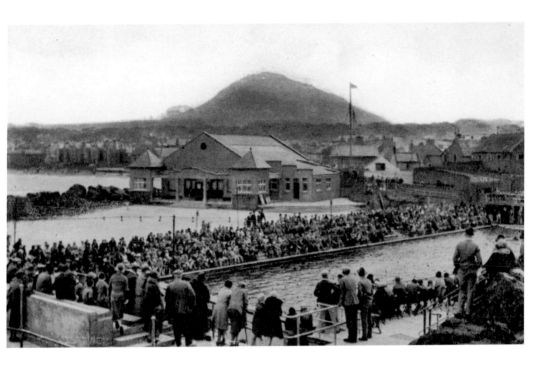

Outdoor Swimming Pool

Open-air swimming pools were fashionable throughout the twentieth century at holiday resorts. North Berwick was no exception, and funds were raised by public subscription to build one next to the harbour. It opened in 1905 and proved to be great success, holding galas, swimming and beauty competitions, and being a focal point for entertainment. Its popularity gradually declined and it closed after the summer season in 1995, despite local opposition. The site is now a park for dinghies; a severe storm flooded it in 2010.

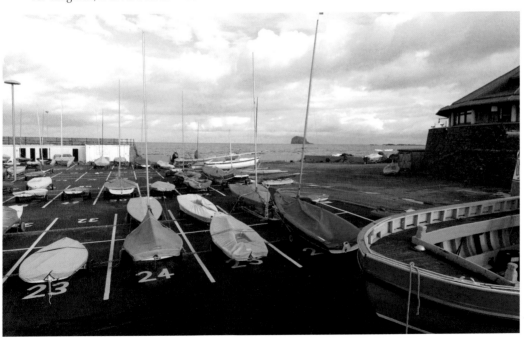

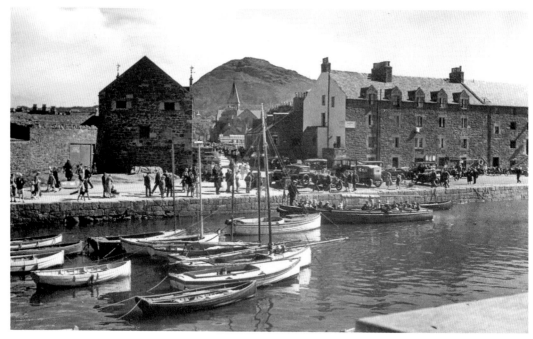

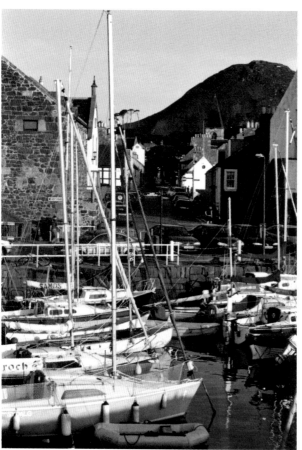

North Berwick Harbour

The harbour we see today has evolved over centuries of alterations, repairs, deepening and building. Fishing became significant during the 1800s, with up to thirty boats operating at the height of the herring trade. Two granaries were built in 1806 and 1811, but turnips and flour gradually replaced grain, and rail traffic took freight away from the sea, so these were converted into living accommodation. Paddle steamers brought throngs from Edinburgh until wartime. East Lothian Yacht Club, started in 1928, has gone from strength to strength and its members comprise the main craft filling the harbour now.

Platcock Rocks

Pilgrims put North Berwick on the nautical map. By the mid-1400s, up to 15,000 a year were making their way to St Andrews from Northumberland and the Borders, crossing the Firth of Forth to Earlsferry in Fife. At that time, the harbour was no more than a breakwater constructed along a ridge from the Platcock rocks, no doubt a precarious way to board the ferry. In 1889, the Coastguard Semaphore lookout post was erected on the rocks.

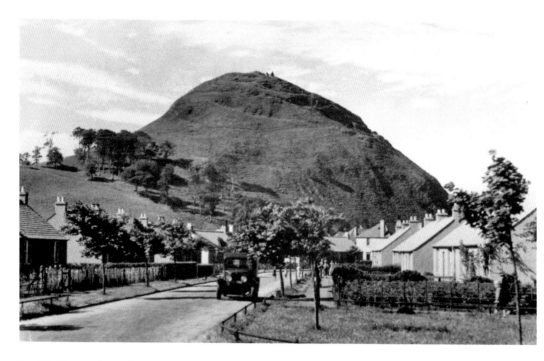

Lochbridge and North Berwick Law

The 613-foot high volcanic plug of Berwick Law is a marvellous vantage point from which to see East Lothian's topography, and the remains of a Napoleonic signal station and a Second World War lookout post survive on the summit. In the 1920s, when families were often still large, overcrowding was a problem and the town council began to build more housing such as these in Lochbridge; one of the last road tax toll-houses was sited here and pulled down in 1930.

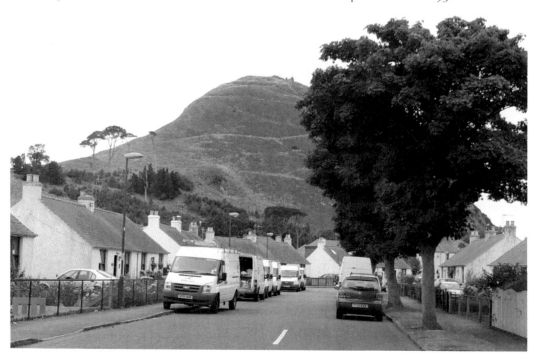

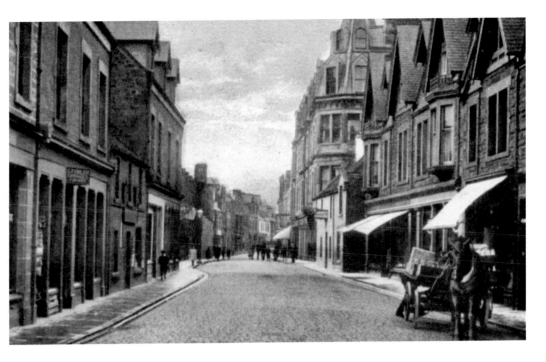

North Berwick High Street

The opening of the railway roughly coincided with the decline of fishing, and the combination changed the basis for North Berwick's future prosperity. Day trippers and holidaymakers poured into the seaside resort – six hotels were built before the turn of the century, while enterprising residents began to offer bed and breakfast and more people chose to live in the town permanently. Consequently, the High Street blossomed with new shops and businesses.

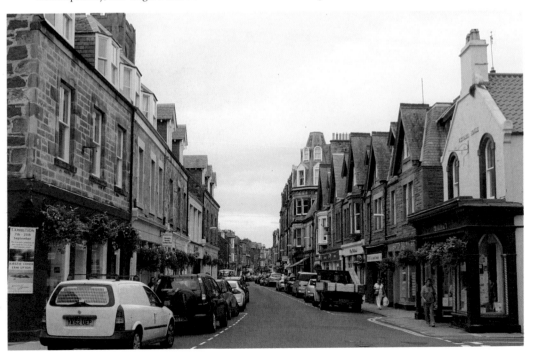

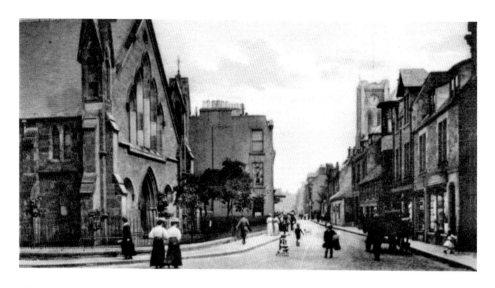

High Street and Abbey Church

This church was built in 1868 during an era of great change in the town. Behind it, the land ran down to West Bay; this was used as a dumping ground for waste until the 1780s, when Forth Street came into being. In 1817, the town council erected a stone wall at high-tide level (still visible today), and a road was built to the harbour. Gas lighting came in 1845 (although not used on moonlit nights!), and by 1870 most properties had running water. The population grew from 1,824 in 1801 to 3,038 in 1891, and now stands at 6,380 – change indeed.

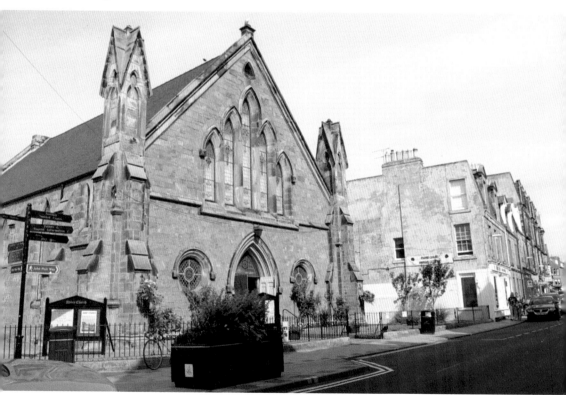

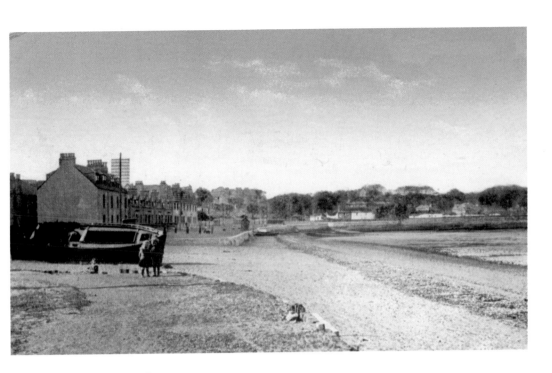

Fisherrow Promenade

Fisherrow is a community whose livelihood came almost exclusively from fishing. It is on the east bank of the River Esk, which divides it from Musselburgh, of which it is essentially a suburb. In 1626, there was merely a wooden pier, so at the start of the eighteenth century, plans were drawn up to build a harbour nearer to the mouth of the river, but this idea was shelved due to the estuary silting up. The stone one was eventually built in 1850. Today, the promenade is the starting point for the John Muir Way – a 45-mile coastal path.

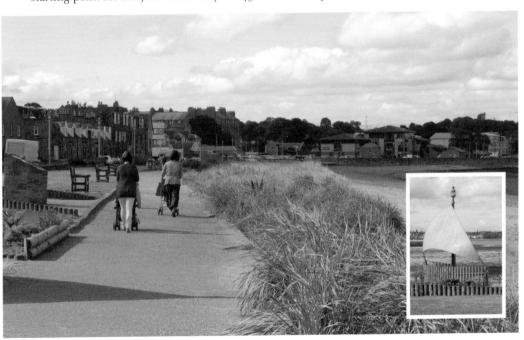

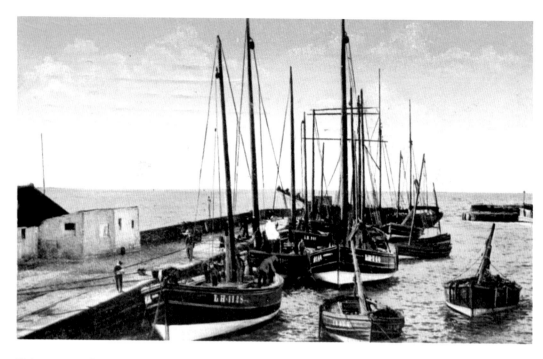

Fisherrow Harbour

The water here is shallow and the harbour dry at low tide – the reason it was rejected by Oliver Cromwell in 1650, in favour of Dunbar. Fishing in the Firth of Forth was mostly for white fish, but during July and August 'The Drave' was all about herring, and this fishing was undertaken in darkness. After a lull in catches in the late 1700s (seven boats in 1791), nineteenth-century fleets expanded (twenty-eight boats in 1839) and 'winter herring' sustained the industry, but it declined rapidly in the 1930s, and ceased at Fisherrow around 1950. Fisherrow Yacht Club was founded here in 1957, and today's harbour remains busy, albeit with pleasure craft.

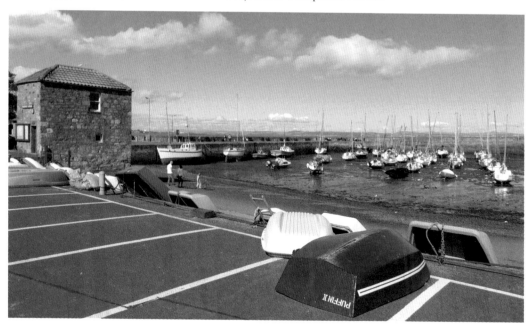

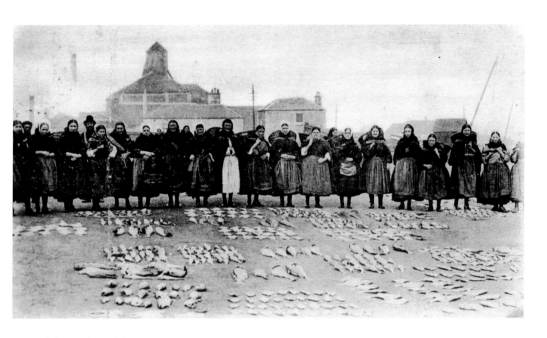

Fish Market, Fisherrow

The fishwives of Fisherrow (and Newhaven) were remarkable, tough women. The men went out in the boats, but the catch thereafter was handled by the women – frequently their wives – who carried fish-laden creels on their backs to the market in Edinburgh. Their 'uniform' of blue and white striped cloth was unique. The last fishwife who worked here was Betty Millar, who died in 2000.

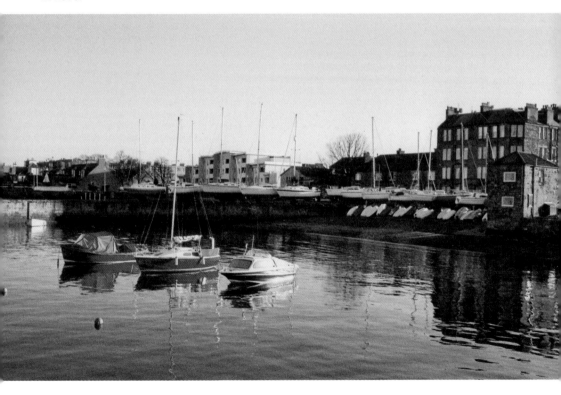

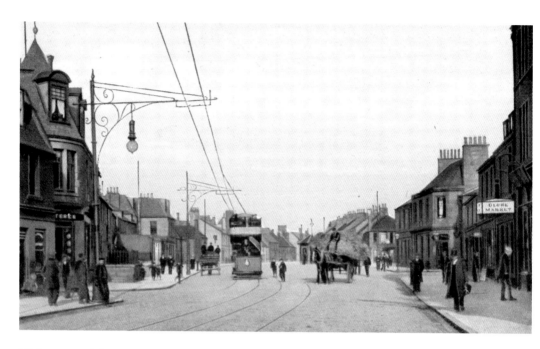

High Street, Fisherrow

In 1904, an electric tramway was opened between Joppa and Levenhall, which served Fisherrow and Musselburgh for fifty years. The tram looks incongruous next to the horse-drawn cart in the photograph. Brunton Hall was built in 1971 with money left to the Musselburgh community by the family who owned Brunton's Wire Works, a major local industry that closed in 1992. A supermarket now fills the site.

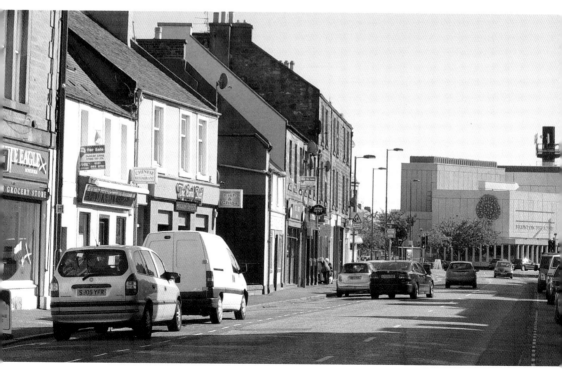

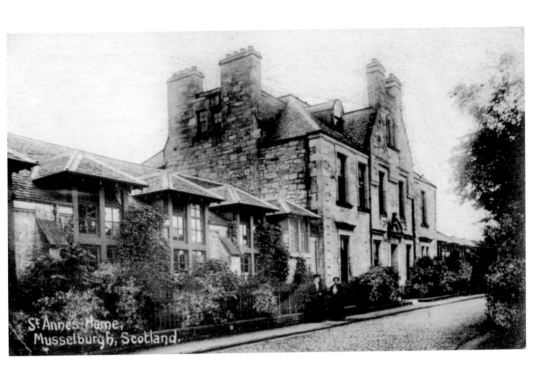

St Annes Home, Musselburgh, Scotland.

St Anne's Care Home

St Anne's Convent is on the eastern fringe of Musselburgh in a tranquil square. It is owned by the Sisters of Charity of St Paul the Apostle and has been used as care home since 1907. The nuns retired from the active duties in 1999 and lay staff are now employed. The links across the road are home to a different world, that of horse racing. In 1816, race meetings moved from Leith to Musselburgh, although the 'Edinburgh Racecourse' title was only changed in 1990.

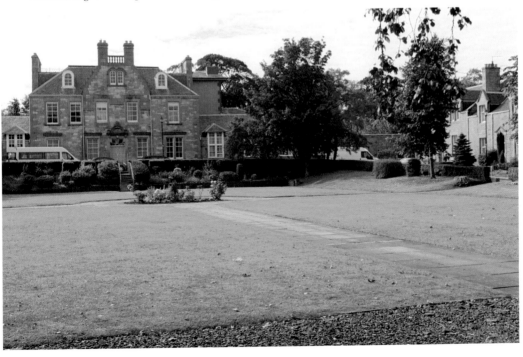

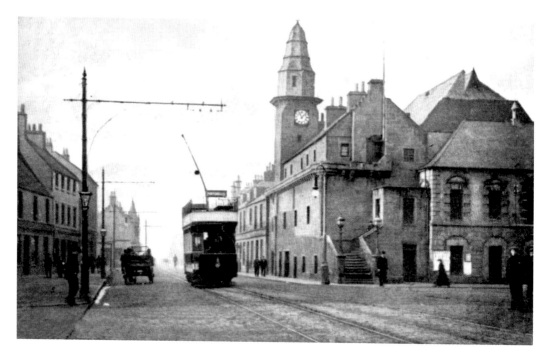

Town Hall, Musselburgh

The original tollbooth was destroyed during the 'rough wooing' campaign in the 1540s, and was rebuilt in 1590 with materials from the wrecked Chapel of Our Lady of Loretto. The clock tower is dated 1496 and is thought to have been given to the burgh by the Dutch, with whom Fisherrow had a thriving trade. An external staircase is the sole entrance to the first floor. In 1731, an eastern extension incorporated a courtroom, and then in 1900, the town hall, fronted by a three-bay façade, completed the large structure seen today.

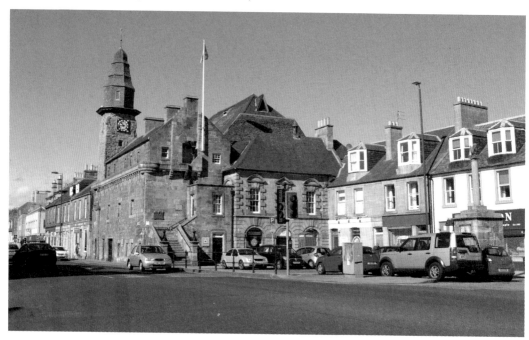

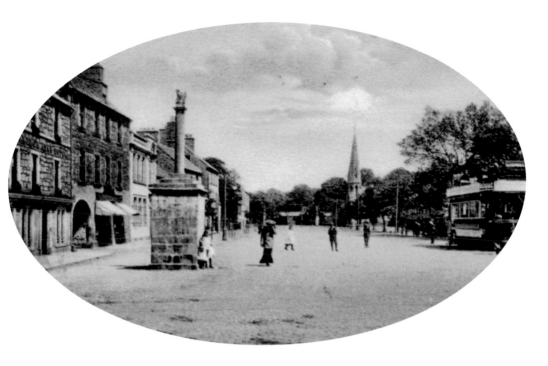

The Cross, Musselburgh

The mercat cross is situated at the eastern end of the High Street, near the tolbooth, where the thoroughfare is markedly wider. This space was created when a row of houses (Midraw) was cleared, resulting in a pleasant avenue now lined with cherry trees, leading past St Peter's church to the Pinkie Pillars of 1770, which mark the eastern entry to the town.

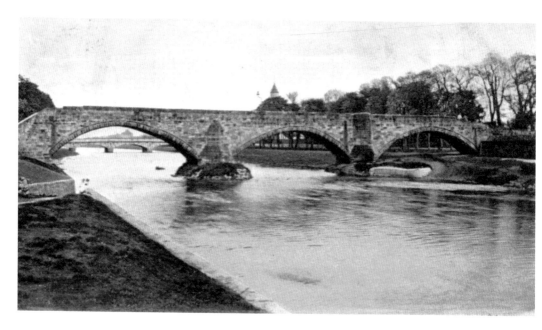

The Bridges, Musselburgh

The route from England to Edinburgh needed to cross the River Esk, and this bridge, still known as 'Roman Bridge', has its foundations in that era. It was rebuilt in the sixteenth century, when a third arch was added. The pedestrians crossing today tread the same steps as those of Bonnie Prince Charlie as he headed to Prestonpans in 1745. The road bridge downstream was designed by John Rennie, the accomplished civil engineer from East Linton.

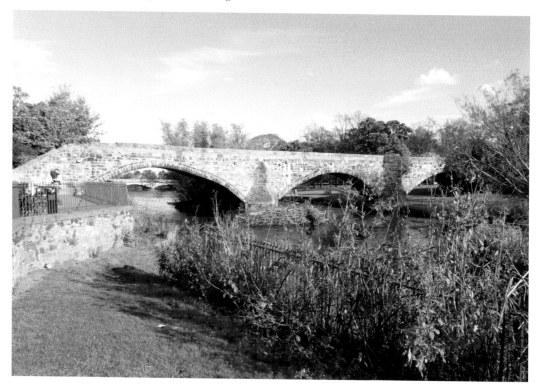

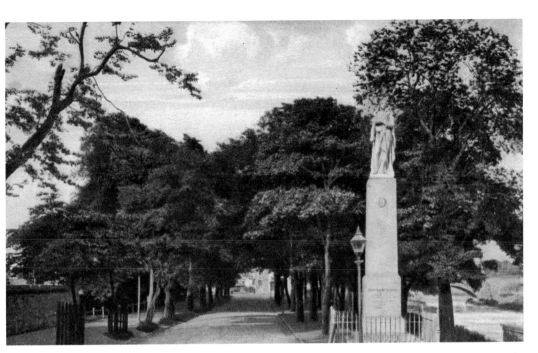

The Mall, Musselburgh

The eastern bank of the River Esk, upstream from the High Street, is an avenue of trees and parkland. Mall Park was threatened when the railway station was being built further up the road in 1845 but, thanks to the fervent efforts of a local minister, the North British Railway left it unspoilt. A few years later, a large statue commemorating Dr David 'Delta' Moir – Musselburgh physician and writer – was erected at the corner of the Mall.

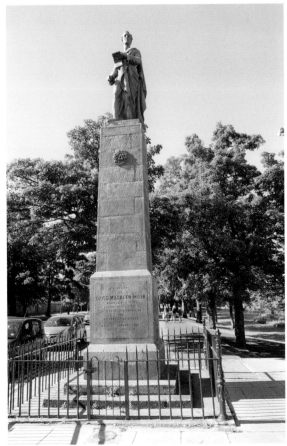

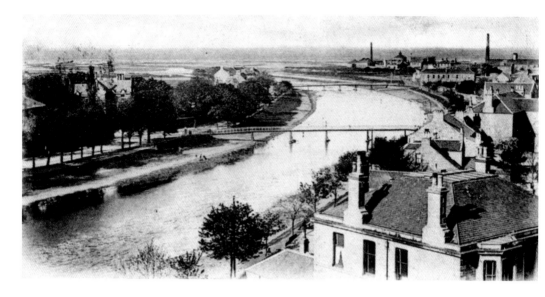

The River Esk

The river has been central to Musselburgh's long history, from the crossing made by the Romans to the water power utilised by paper, fishing net and textile mills, not forgetting the extensive mussel beds at the estuary, after which it was named. These industries have mostly died out and the buildings either converted to offices or cleared for housing. Nonetheless, the population has grown to almost 22,000 in the twenty-first century.

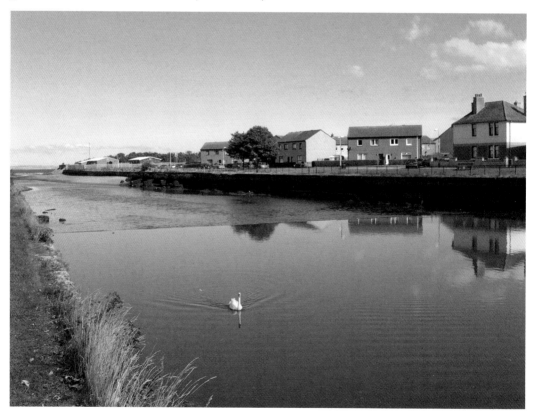